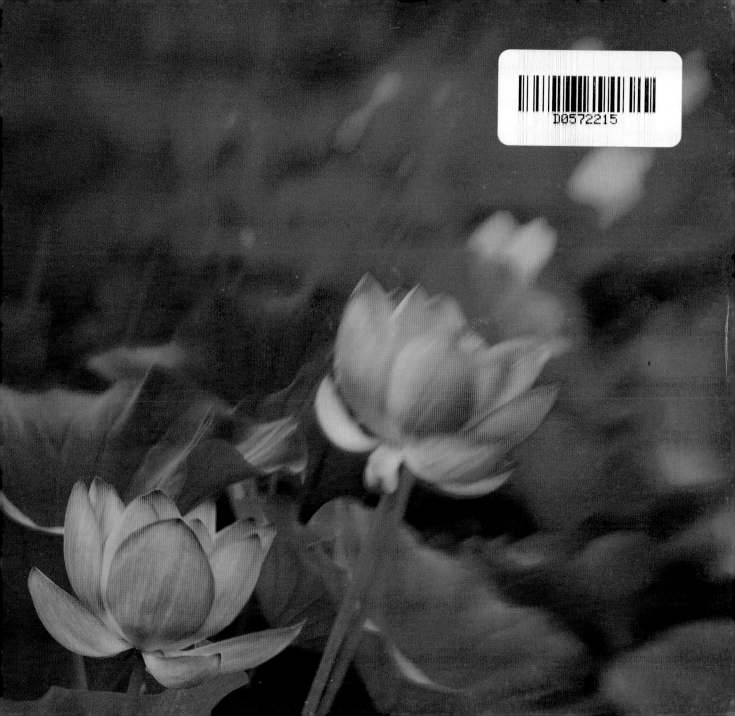

Corey Hilz

LENSBABY

BENDING YOUR PERSPECTIVE

Focal Press is an imprint of Elsevier
30 Corporate Drive, Suite 400, Burlington, MA 01803, USA
The Boulevard, Langford Lane, Kidlington, Oxford, OX5 1GB, UK

Notices

Knowledge and best practice in this field are constantly changing. As new research and experience broaden our understanding, changes in research methods, professional practices, or medical treatment may become necessary.

Practitioners and researchers must always rely on their own experience and knowledge in evaluating and using any information, methods, compounds, or experiments described herein. In using such information or methods they should be mindful of their own safety and the safety of others, including parties for whom they have a professional responsibility.

To the fullest extent of the law, neither the Publisher nor the authors, contributors, or editors, assume any liability for any injury and/or damage to persons or property as a matter of products liability, negligence or otherwise, or from any use or operation of any methods, products, instructions, or ideas contained in the material herein.

Library of Congress Cataloging-in-Publication Data
Application submitted

British Library Cataloguing-in-Publication Data
A catalogue record for this book is available from the British Library.

ISBN: 978-0-240-81402-5

For information on all Focal Press publications
visit our website at *www.elsevierdirect.com*

Printed in China
10 11 12 13 14 5 4 3 2

Typeset by: diacriTech, Chennai, India

Working together to grow
libraries in developing countries

www.elsevier.com | www.bookaid.org | www.sabre.org

ELSEVIER BOOK AID International Sabre Foundation

CONTENTS

	Introduction	viii
Chapter 1	**The Lenses**	**3**
	Which Lensbaby Is Right for Me?	4
	Meet the Lensbabies	7
Portfolios	**A Taste of My Lensbaby Vision**	15
Chapter 2	**Using Your Lensbaby**	**27**
	Exposure and the Lensbaby	28
	Focusing and the Sweet Spot	29
	Aperture Discs	47
Portfolios	**Portrait: Peggy Dyer**	57
	Wedding: Kevin Kubota	57
Chapter 3	**Optics**	**71**
	The Optic Swap System	72
	Optic Comparison	75
	Double Glass Optic	77
	Single Glass Optic	79
	Plastic Optic	82
	Flare and Chromatic Aberration	84
	Pinhole/Zone Plate Optic	86
	Soft Focus Optic	92
	Fisheye Optic	100
Portfolios	**Commercial: Jim DiVitale**	115

Chapter 4	**Accessories**	**123**
	Accessories	124
	Macro Kit	124
	Wide Angle/Telephoto Kit	129
	Super Wide Angle Lens	133
	Creative Aperture Kit	137
	Step-Up/Shade	145
	Custom Lens Cases	146
Portfolios	**Landscapes: AJ Schroetlin**	**147**
	Flowers: Tony Sweet	**147**
Chapter 5	**Lensbaby Vision**	**161**
	Self-Assignments	162
	Aperture Considerations	163
	Streaking	165
	Let the Focus Go	167
	Shooting Through	171
	Reinventing the Ordinary	173
	Timing	176
	Best Optic for the Job	181
Portfolios	**Urban Details & Architecture: Jerome Hart**	**189**
	Urban Lifestyle: L. Toshio Kishiyama	**189**

Chapter 6	**Creative Ideas**	**203**
	Overlays	204
	Multiple Exposures	210
	Filters	213
	Black and White	221
	Flash	226
	Video	227
Portfolios	**Wait! There's More!**	**229**
Chapter 7	**Troubleshooting and Common Questions**	**243**
	What's Going On with My Lensbaby	244
Portfolios	**Community Gallery**	**247**
Wrap-up		**255**
Subject Index		**257**

INTRODUCTION

The purpose of this book is to share the possibilities of what you can do with a Lensbaby. The Lensbaby is a fun and creative tool, and there is no shortage of ways to use it in your photography. Whether it's trying out the various optics and accessories or experimenting with a shooting technique or style, there are always more possibilities to explore. While working on this book I looked at thousands of Lensbaby photos other than my own and was energized by the amazing Lensbaby photography that is being created around the world.

When I began photographing with a Lensbaby, it took practice to get used to bending and squeezing the lens. It was completely different from other lenses I'd used, and the photographs I created were like nothing in my photo library. Though not always in a good way! I've taken my share of bad Lensbaby photos, so don't be discouraged if you're just getting started or trying out a new optic or accessory and your photos don't turn out as you expect. After you've got the basics, jump right in and enjoy the process. As with any equipment, the more time you can spend using it, the more comfortable you'll be with it. Give yourself the freedom to experiment, make mistakes, and take those not-so-great photographs. Learn what worked and what didn't, then use that knowledge to take better pictures the next time.

The book alternates between chapters and portfolios, with as many photos stuffed into both as possible. The chapters are packed with examples and offer detailed information about everything from exposure and focusing to optics and accessories. The portfolios are full of images, insights, and stories to get you inspired and spur your imagination. You'll find photographs taken by myself and other talented Lensbaby photographers that show a diverse collection of styles and subjects. Thanks to the photographers who contributed photos and shared their knowledge about using Lensbabies: John Barclay, Kathleen Clemons, Mark Cornelison, Jim DiVitale, Joye Ardyn Durham, Peggy Dyer, Jerome Hart, Axel Heimken, Kirsten Hunter, Sergej Karssen, L. Toshio Kishiyama, Michael Koerner, Kevin Kubota, Luca Lacche, AJ Schroetlin, Stacey Shackford, Lisa Smith, Craig Strong, Tony Sweet, and Oliver Tudoras.

Never stop experimenting and practicing. During the process of writing this book I've continued to expand my Lensbaby skills. So whether your Lensbaby is fresh out of the box or well used, I hope this book helps you improve your Lensbaby vision. Whatever you like to photograph, you can shoot it with a Lensbaby!

A Brief History of the Lensbaby

With very modest sales expectations, Craig Strong and Sam Pardue launched Lensbaby at the February 2004 Wedding and Portrait Photographers International trade show in Las Vegas. The Original Lensbaby was so well received that Craig and Sam sold all their meager stock the first day and for the remainder of the show worked late nights assembling as many Lensbabies as they could in their hotel room, only to sell out before the end of each of the two remaining days of the show. Within six months of launching Lensbaby, Craig and Sam had sold lenses to photographers in 40 countries around the world.

Since that original model, the Lensbaby has been on a path of evolution. With a bendy center that looked like an accordion or a bellows, the design itself certainly drew attention. It offered a unique look that had something called a "sweet spot," which meant one part of the photo was the sharpest and the rest was heavily blurred. Sounds a bit like using a wide aperture on any lens, but the Lensbaby had more to it. The sharp area, or sweet spot, is actually circular, which is not what you'd get from a "regular" lens. Think of the sweet spot as an area of concentrated focus. To further separate it from other lenses, you could bend the Lensbaby to control the placement of the sweet spot. After the Original Lensbaby came the Lensbaby 2.0, in 2005. It looked much like the original but offered a sharper sweet spot. The 2.0 version was my introduction to the Lensbaby. Although I was no stranger to working with a shallow depth of field, this lens offered a look that was unlike any photographs I'd created. I was instantly hooked and particularly enjoyed using it for my flower photography.

In 2006 the Lensbaby evolution continued with the Lensbaby 3G. It was a design that was strange yet familiar. It still had that accordion-like center, but it also sported three rods and a focusing ring. Funky looks aside, the 3G opened up new possibilities for my Lensbaby photography. I could lock the lens in place instead of having to hold it with my fingers, giving me the ability to use slow shutter speeds and still get sharp images. The next generation of Lensbaby, announced in 2008, was a big change for the lineup. A redesign to the lenses brought in a new era of Lensbaby options. There was a new lens called the Composer. Instead of the bendy middle of previous Lensbabies, the Composer had a ball-and-socket connection. At the same time the Lensbaby 2.0 and 3G were redesigned and rebranded the Muse and the Control Freak, respectively. With these three lenses also came the Optic Swap System. This new system allowed you to change out the glass (the optic) inside the Lensbaby. This opened up a world of creative possibilities, moving the Lensbaby from a lens that was all about the sweet spot to one that offered many additional creative possibilities.

The folks at Lensbaby aren't sitting still. They continue to innovate, coming up with new ways we can use the Lensbaby as a creative tool in our photography. I look forward to seeing what they have in store for the future!

All photos © Corey Hilz, unless otherwise noted.

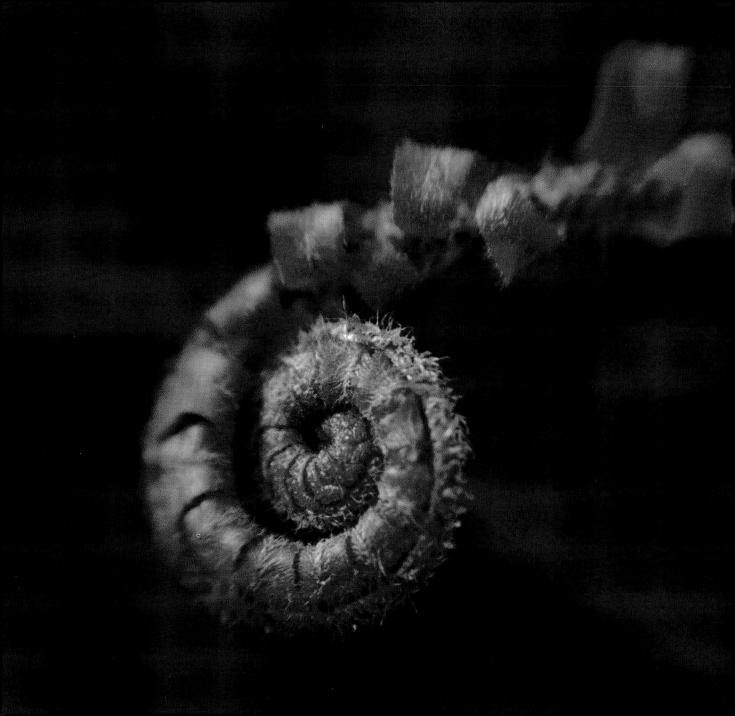

THE LENSES

There are three current models of Lensbabies: the Composer, the Muse, and the Control Freak. Previous models are the Original Lensbaby, the 2.0, and the 3G. These models all work in different ways but are based on the same idea of bending or tilting the lens to control the part of the image that is in focus. The cornerstone to the Lensbaby look is the sweet spot, the area of the photo that's the sharpest. Bending the lens allows you to change the location of the sweet spot. Certain accessories for these lenses offer the ability to produce other creative effects besides a sweet spot. (You can find details on those in Chapter 3.) For now let's take a look at what each lens has to offer and how the lenses work.

Which Lensbaby Is Right for Me?

Each Lensbaby has its own look and feel. Your shooting style and the subjects you photograph will be the greatest influence on deciding which lens is right for you. However, because each lens has its own strengths, you may find yourself wanting a couple to use for different situations!

Composer

The Composer is the easiest to get started with if you have never used a Lensbaby before. If you're moving up from an earlier model, the Composer's design is straightforward and intuitive. Compared to the 3G, the Composer has fewer adjustments you have to think about. The ball-and-socket mechanism makes it simple to move the sweet spot around. It offers great control combined with the most intuitive design of the three lenses. The focusing process is similar to that of using a focusing ring on a regular SLR lens. Also, you don't have to be concerned with holding the lens in place or locking it in position.

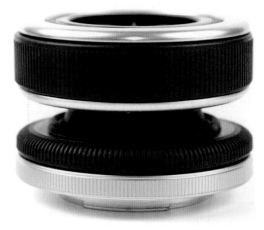

Composer

Muse

The Muse complements a looser shooting style. It allows you to be spontaneous, quickly reacting to what's happening around you. To use the Muse most effectively, you'll need to be comfortable with the squeezing and bending process. Once you're adept at using your fingers to focus, you can quickly shift the point of focus (the sweet spot) around the viewfinder. The Muse offers the benefit of bending back to the "starting" position (pointing straight ahead) once you let go of it. Although this feature doesn't lend itself to repeating the same shot, you will always know where the Muse is pointing when you begin to bend the lens. The fluid nature of the Muse makes it useful for fast-changing situations or unplanned moments where you just want to squeeze, bend, and shoot. The Composer's design doesn't make it convenient to bend and focus at the same time.

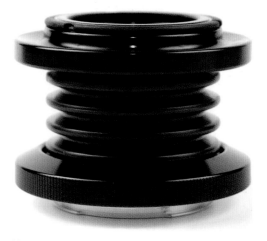

Muse

Control Freak

The Control Freak offers a step-by-step process to taking a photograph. It gives you precise control over each of the Lensbaby's adjustments. This precision also means that you have to go through a number of steps for each image: squeeze and bend, lock the lens in place, adjust the focus. The features of the Control Freak position it between the Muse and the Composer. It offers the bending and squeezing of the Muse, but then you can lock the lens in place and fine-tune the focus. This design gives the lens a dual functionality. You can use the Control Freak as though it were a Muse, while at the same time you always have the locking and fine-focusing features available. After you lock the lens in place, the rods also make it possible to ever so slightly adjust the angle of the lens. The Control Freak can be useful for studio photography and other situations in which exacting setups are required.

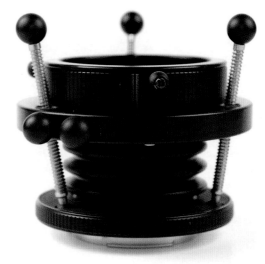

Control Freak

Meet the Lensbabies

Let's take a look at the Lensbabies we'll discuss in this book. (For step-by-step instructions on focusing and composing, see Chapter 2.)

Composer

The Composer offers a balance between ease of use and precise control. A significant difference between the Composer and the Muse or Control Freak is that there is no bendy middle to the lens. In its place is a ball-and-socket connection. So, instead of literally bending the lens, you tilt it. Let's look at other similarities and differences between the Composer and the other Lensbaby lenses.

The Composer has a large focusing ring, similar in function to the one on the Control Freak. However, the Composer's focusing ring is a more significant feature. Since you don't squeeze the Composer to set the focusing distance, the focusing ring takes over this role. It combines the squeezing and the focus fine-tuning into one adjustment. Due to its larger size, it might remind you more of the focusing ring on one of your regular lenses. It has a broad range, allowing you to set focus from the minimum focusing distance to infinity. With the Composer you'll want to start with the lens

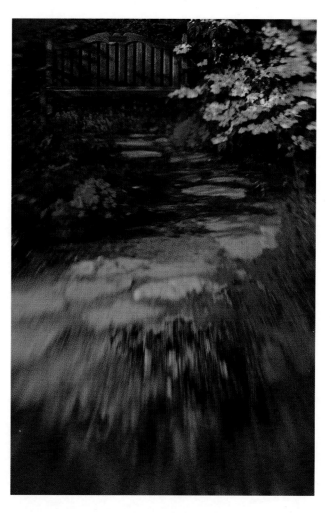

Lensbaby Composer, Double Glass Optic, f/4

This is one of the first photos I took with the Composer.
With its ball-and-socket connection, it was easy to tilt the lens way up to bring just the bench into focus at the top of the image. Notice the heavy blurring caused by the extreme tilt of the lens.

pointing straight ahead. (It doesn't "spring back" to the center as with the other lenses; you have to reposition it yourself.) Then use the focusing ring to focus at the distance where your subject is located. The closest you can focus is about 18 inches from the front of the lens. Now to move the sharp area away from the center, simply tilt the Composer in the direction in which you want it sharp. No need to lock it or hold it in place; it stays where you put it. Once you have the sweet spot where you want it, use the focusing ring to tweak the focus.

At the base of the Composer (where it mounts to your camera) is a black locking ring to control the tension of the ball-and-socket connection. For the least amount of tension, turn it as far as you can to the right (when looking at the Composer from the back). This is where I usually leave it. Even with minimal tension the lens will stay where you tilt it; it

won't flop around. If you turn the locking ring all the way to the left, the lens is completely locked down. This is useful if you want to make sure the lens absolutely, without a doubt, won't move at all.

Muse

The features described and the steps for using the Muse also apply to the Original Lensbaby and the Lensbaby 2.0.

The Muse is the most free-form and spontaneous of the three lenses. You just squeeze, bend, and shoot; simple and straightforward. The accordion-like center of the lens allows you to focus close or far away, depending how you squeeze the lens. If you look through the viewfinder and don't touch the Muse, it's set to focus at the closest possible distance. The Muse's closest focusing distance is about 14 inches (from the front of the lens). If you're

Extreme Bending

The Composer handles extreme bending well. Tilt it to one extreme or another and you can still bring part of the subject into focus near the edge of the photo. For instance, tilt the lens way to the left, then use the focusing ring to bring something close to the left edge into focus. Be aware that you can tilt the lens so far that the sweet spot will fall outside what you see in the viewfinder. Then you won't be able to bring anything into focus, because what would be in focus is not visible in the viewfinder. So, if you've done an extreme bend and you can't get anything in focus, you may have tilted the lens too far.

Lensbaby 2.0 (double glass), f/4

With the camera held steady on a tripod, my biggest concern was holding the lens still during the exposure, which was 1/20th of a second. When working with slow shutter speeds, take at least a few photos to ensure that you come away with a sharp one. This approach landed me a shot that was tack sharp on the blossoms.

taking a close-up photo, try not touching the lens and just move the camera further from or closer to the subject until it's in focus. You'll be getting the closest possible shot and you don't have to worry about holding the lens steady because you didn't squeeze or bend it.

To get a feel for how close a shot you can get, try this: without bending or squeezing the lens, move closer and closer to an object until it's in focus (watch the center of the viewfinder). Once the object is in focus, stop and look at how far you are from it. That's the minimum focusing distance: the closest you can be to an object and still have it in focus.

To focus further away, squeeze the Muse toward you. Place two fingers on either side of the Muse for the most control when squeezing and bending. The more you squeeze the lens, the further away it focuses—all the way to infinity or anywhere in between. If you squeeze it evenly (no bending), the middle of the viewfinder comes into focus. Want to focus on something to the left, right, top, or bottom? Just bend the lens as you squeeze it. Bend the Muse in the direction that you want something in focus. For example, if you want a person on the left side of the viewfinder to be sharp, bend the lens to the left. You'll have to squeeze the lens while bending it to focus at the correct distance.

When the area you want in focus is sharp, hold the Muse as still as possible while you snap a picture. Since your fingers control the position of the Muse, they also control whether the lens stays still. To get a sharp picture, neither the lens nor the camera should move during the exposure. Try to use a shutter speed that is 1/60th of a second or faster. If the shutter speed is too slow, your fingers won't hold the lens still during the entire exposure, resulting in a blurry photo.

Faster Shutter Speeds

Increase your ISO to achieve a faster shutter speed. If you're working in Aperture Priority mode, the shutter speed will automatically increase when you raise the ISO. If you're in Manual exposure mode, you'll need to change the shutter speed yourself after changing the ISO. Every time you double the ISO, double the shutter speed to maintain the same exposure. For example, let's say that the original exposure is 1/15th of a second at ISO 200. If you change the ISO to 400, you'd then increase the shutter speed to 1/30th. Go to ISO 800 and the shutter speed would be changed to 1/60th.

Control Freak

The features described and the steps for using the Control Freak also apply to the Lensbaby 3G.

The Control Freak takes the design of the Muse and gives you more precise control of the bending and focusing. One of the challenges of working with the Muse is the need to use fast enough shutter speeds so that you can hold the Muse steady during the exposure. This can be particularly challenging in dim lighting when you'll need slower shutter speeds. The Control Freak offers a convenient solution. It has a locking button on the center ring of the lens (the one the rods go through). Once you've brought your subject into focus and have the sweet spot where you want it (the same way you use the Muse), press the locking button and the lens stays put. The three metal rods are used to lock the lens in place so you don't have to hold it steady yourself. Besides working in low-light conditions, this locking capability also makes it easy to take multiple photos with the exact same composition and point of focus. No need to try to keep your fingers frozen in the same position for picture after picture; the Control Freak does it for you.

After you have the Control Freak locked down, use the focusing ring to fine-tune the focus. This enables you to make sure you get the focus in just the right spot. For further tweaking, you can turn the metal rods to adjust the bend of the lens. However, if the focus and sweet spot are right where you want them, no need to twist the rods. I don't often find it necessary to adjust the Control Freak with the rods. I mostly take advantage of the ability to fine-tune the focus. After you've taken the picture, set your Lensbaby free by squeezing together the two knobs on the center ring. This will release the lens, and you're back to being able to bend it however you'd like.

Maximize Minimum Focusing Distance

Need to get a little closer than the minimum focusing distance? Push the front of the Muse out (away from the camera body). It's got a little bit of give, and any distance you can push it away from the camera will allow it to focus closer. This will make it possible to get within eight or nine inches of your subject. However, using the push-out technique will make it tough to bend the Muse at the same time. It works in a pinch. When you're really looking to capture close-up pictures, use the Macro Kit (more about that in Chapter 3).

Lensbaby 3G (double glass), f/4

After locking the 3G into place, the fine-focus ring made it possible to place the focus right where I wanted on the leaves. Even though this photo was taken in the shade, I purposely used a Daylight White Balance setting to create a cooler image (temperature-wise). This helped enhance the natural blue-gray of the rocks. If I'd set the White Balance to Cloudy or Shade, the rocks would have become a neutral and uninteresting shade of gray.

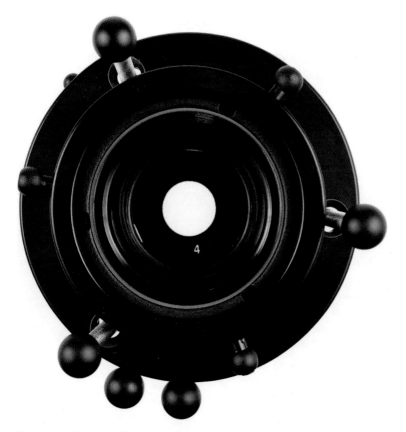

Knobs on the Fine Focus Ring centered between rods for maximum focusing range

Make the Most of the Fine-Focus Ring

The focusing ring has a limited range; it can only go so far in either direction before the knobs run into the rods. Before composing your picture, position the focusing ring to maximize its range. Turn the ring so that the knobs are centered between the rods (see photo on this page). This will allow you to turn the ring an equal amount in both directions.

Lensbaby Composer, Double Glass Optic, f/4

Spotting these street lamps at dusk, I looked for away to place the lights against the fading blue of the sky. Using a Daylight white balance setting brought a green cast to the lights which paired nicely with the cool sky. To add color to the bottom of the photo I found an angle where I could include buildings and street lights in the background.

A TASTE OF MY LENSBABY VISION

portfolios

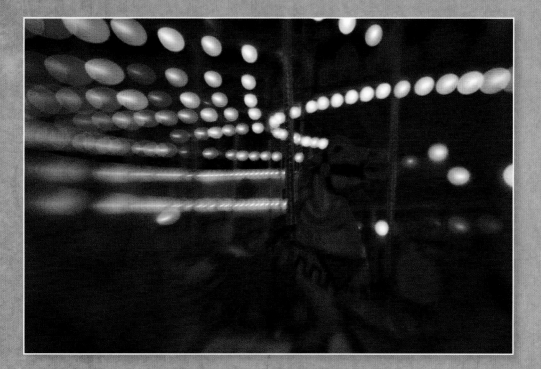

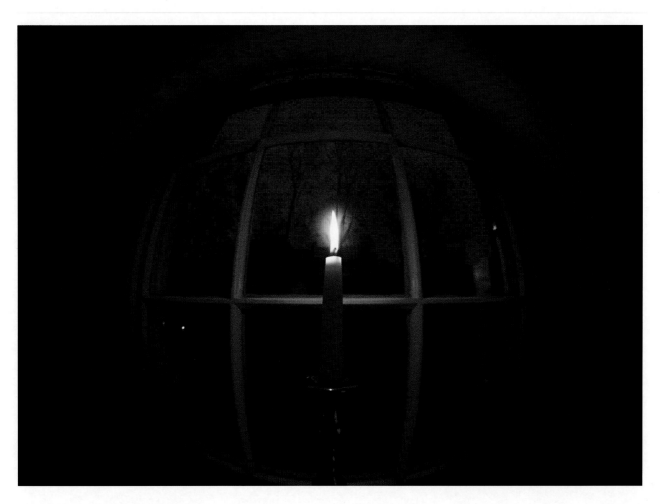

Lensbaby Composer, 12 mm Fisheye Optic, f/4

The warm glow of the candle provided the perfect contrast to the dusk sky outside. The flare adds to the warm feeling created by the candle. Keeping the candle centered in the composition produced an evenly lit flare circle. I used the Tungsten White Balance setting, which further enhanced the cool blue cast of the sky.

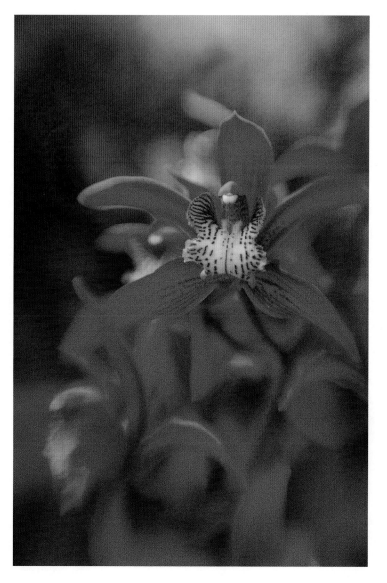

Lensbaby 2.0 (double glass), f/4

I looked for a perspective that would include a colorful background to help the orchid stand out. I placed the sweet spot on the most prominent orchid, which turned the surrounding flowers into a smooth, painterly blend.

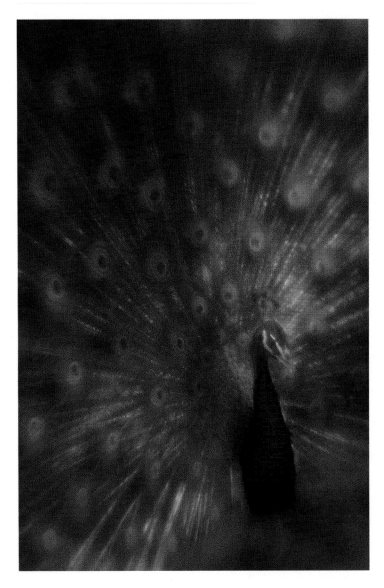

Lensbaby Composer, Single Glass Optic, f/2 (no aperture disc)

My Lensbaby photographs of this peacock displaying are some of my favorites. The combination of the Single Glass Optic and no aperture disc created a slightly ethereal look that shows off the peacock beautifully. All the detail is there but with a soft quality. Photographing from just a few feet away made it possible to capture frame-filling shots.

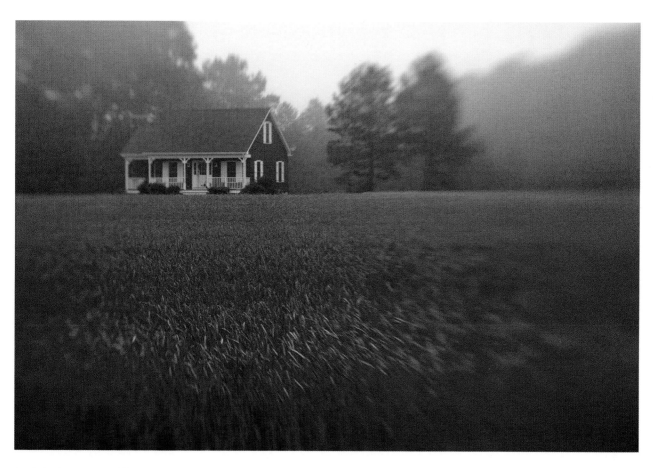

Lensbaby Composer, Double Glass Optic, f/4

The Lensbaby blur was a great pairing for the fog drifting across the scene. The fog creates a mood, plus it complements the softness around the edges of the image. I placed the sweet spot on the house to quickly pull the eye across the field, making the detail in the field less important than its color and expanse.

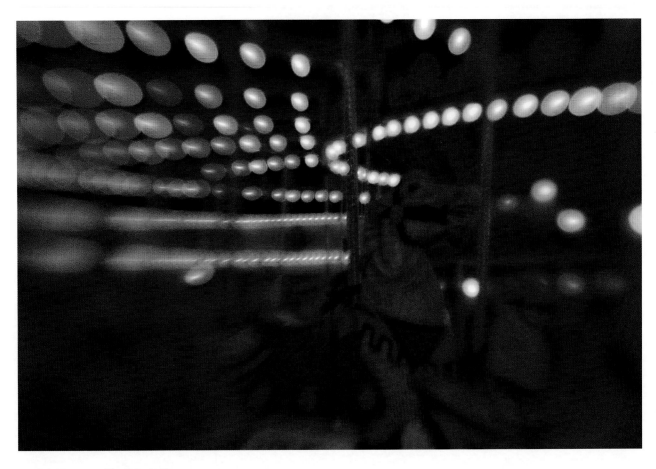

Lensbaby Composer, Plastic Optic, f/4

Standing in front of the merry-go-round, I envisioned a photograph that would show the merry-go-round as it might be imagined in the mind of a child: a warm, inviting scene with glowing lights and colorful horses going round and round. I started with the Double Glass Optic, but it wasn't long before I switched to the Plastic because it would add more glow and produce a softer scene overall. I photographed the horses as they were going around, tweaking the focus and timing the shots to capture the horses in the best position for the composition.

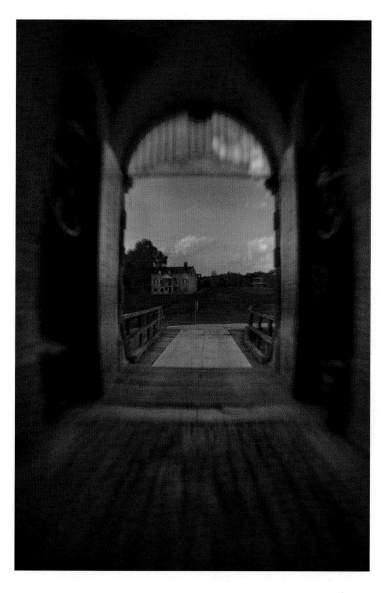

Lensbaby Composer, Double Glass Optic, f/4, Super Wide Angle Lens

To include the view both inside and out, I used the Super Wide Angle Lens. The combination of dim light inside and a bright sky plus direct sunlight outside made it impossible to properly record all parts of the scene in a single exposure. I took eight exposures to capture the full range of detail from light to dark and combined them into an HDR image.

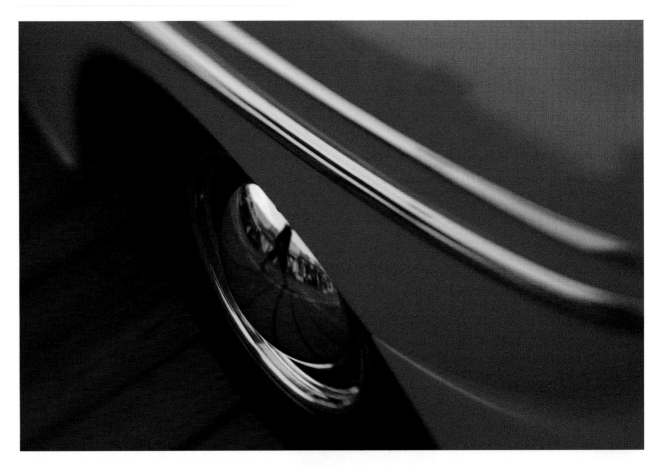

Lensbaby Composer, Double Glass Optic, f/4

Looking for a different perspective on a street rod, I got down low and focused my attention on the reflection in the hubcap. I found an angle that showed a bit of the scene around me on the boardwalk. As people walked by, I timed my shots to try to catch the people in a position where they balanced the other elements in the reflection.

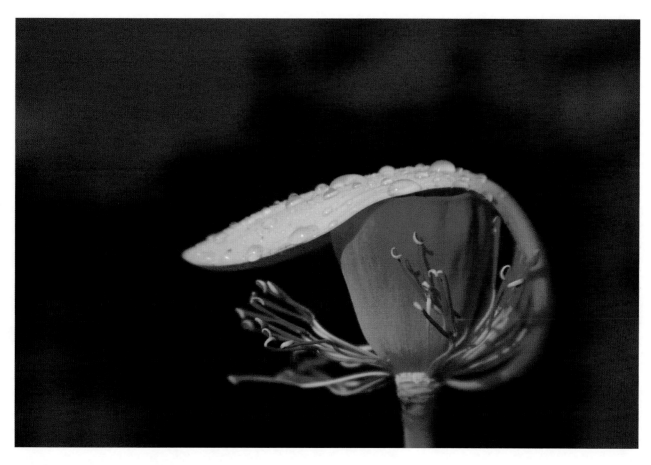

Lensbaby Composer, Double Glass Optic, f/4

I was drawn to the shape of this lotus blossom, which had lost all but one of its petals. I'm always looking for the opportunity to capture lotus portraits of a less traditional nature. This fading blossom fit that description perfectly. I used lotus leaves in the background to frame it against a heavily shaded area.

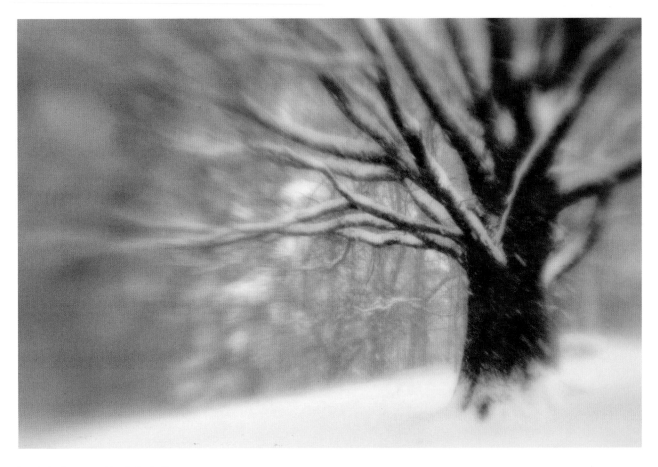

Lensbaby Composer, Plastic Optic, f/4

Instead of waiting for the snow to stop, I headed out while it was still coming down steadily. The falling snow, frozen in the air because I used a fast shutter speed, adds a bit of texture to the image. I liked how the heavy blur as well as the softness of the Plastic Optic makes the viewer feel like they're in the midst of the storm and can hardly see where they're going.

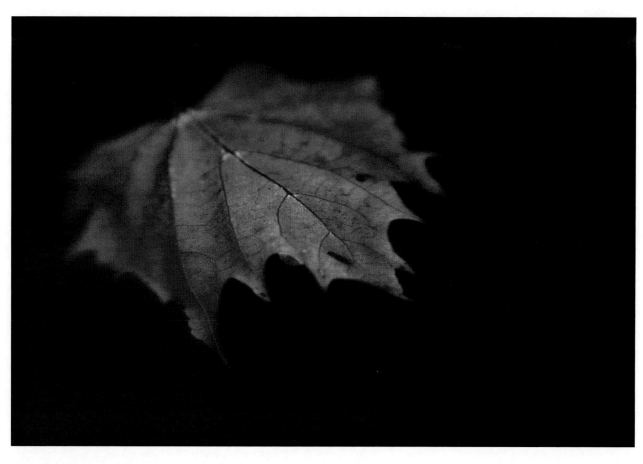

Lensbaby 3G (double glass), f/4

Look for simple compositions to create strong images. No need to clutter up your viewfinder with lots of stuff. Focus your attention on one or two elements. This composition puts most of the attention on the leaf, but the thin line in the background also plays a role. It helps draw the eye back into the image because the line is a light tone and tells the viewer there's something back there. Imagine if there were nothing in the background; the leaf would be in empty, dark water. The composition as a whole would have a very different feeling.

USING YOUR LENSBABY

Exposure and the Lensbaby

When you attach your Lensbaby to your camera for the first time, there are a few settings to review so that you can start taking photos as soon as possible. Most important, you want your camera to be able to "see" the Lensbaby. To make sure this happens, check your exposure mode. Manual exposure mode (M) is always a safe bet. For some camera models, Aperture Priority (A or Av) will also work. You'll want to stay away from Program (P), Shutter Priority (S or Tv), and Auto/Scene modes.

So, why does your camera have trouble with certain modes? It's because your Lensbaby does not have an aperture that functions like that of a regular lens. A regular lens has a mechanism that allows the camera to change the size of the lens's aperture opening. Your Lensbaby came with aperture discs (more on this later in the chapter) that allow you to change the aperture, but the camera has no control over this function. This means you can't use an exposure mode where the camera expects to be able to choose the aperture. Either the camera won't let you take

a photo or, at the very least, something will be flashing at you because the camera can't do what it wants.

In Aperture Priority mode, the camera will control the exposure by picking the shutter speed. To change the exposure, use your camera's Exposure Compensation function (look for a button marked with "+/−"). Choose a positive number for a brighter picture or a negative one for a darker image. Fine-tune the exposure compensation until you achieve a good exposure.

In Manual exposure mode, you'll control the exposure by changing the shutter speed. Your camera may have a metering scale in the

viewfinder with a plus sign on one end and a minus sign on the other. It looks something like this:

When you turn the dial on your camera to change the shutter speed, the series of marks on this scale will shift. The marks may be to the left of zero (as above) or to the right.

For your initial exposure, try adjusting the shutter speed so that there is just a single mark below the zero, like this:

While pointing the camera at your subject or scene, turn the dial to change the shutter speed until you have the single mark. Take a test shot and review the picture on your LCD screen to check the exposure. If your photo is too dark, change the shutter speed to add marks toward the plus sign. If it's too light, add marks toward the minus sign. Continue to take test shots each time you change the shutter speed until the exposure looks good.

Some cameras might not display a metering scale when the Lensbaby is attached, even in Manual mode. The best way to figure out the correct exposure in this situation is some form of "guess and check." It may not be high tech, but it works! Start by taking a test shot and see if it's too light or too dark. Go to a slower shutter speed if it's too dark and a faster one if it's too light. Take another test photo and repeat the process until you have a good exposure.

Focusing and the Sweet Spot

A lot of Lensbaby photography is about that small area of the photo that is in focus: the sweet spot. For a number of years the Lensbaby has been very much about the sweet spot. Where do you place it? How do you move

No Aperture Number

Wherever you normally see an aperture number on your camera's LCD display, it'll likely read "--" or "00." That's perfectly fine, nothing to worry about. Since your camera doesn't know what aperture your Lensbaby is using, it can't display an aperture number.

Guess and Check Tip

Another guess and check option is to use a regular lens to help you get closer to a proper exposure. Put a regular lens on your camera and change to Aperture Priority mode. Then change the aperture to match the aperture disc you're using in your Lensbaby. Remember what shutter speed the camera selects when you point the camera at your subject. Now put your Lensbaby back on, switch to Manual mode, and choose the shutter speed the camera selected for the regular lens. You'll be much closer to a proper exposure. Adjust the shutter speed to fine-tune the exposure.

it around? Now the game has changed a bit with the option to use different optics with current Lensbaby lenses. The following optics do not have a sweet spot: Pinhole/Zone Plate, Soft Focus, and Fisheye (more about these and other optics in Chapter 3). This means that bending or tilting the Lensbaby won't significantly affect the look of photos taken with these optics. If you're using the Original Lensbaby, Lensbaby 2.0, or Lensbaby 3G, you'll always have a sweet spot because the optics in these lenses can't be changed.

Optics or lenses with a sweet spot have a curved field of focus. This means that the sharp area of your photo is actually round. Think of drawing a circle around the spot where you focused. If you bring the center of your viewfinder into focus, the areas that stay the softest are the left and right sides for a horizontal photo, and the top and bottom for a vertical. Regular lenses have a flat field of focus, which means there is a line, or slice, across your entire photograph that is all in focus at the same distance. Take a look at the differences between these three photos.

SHOOTING IN LOW LIGHT

If you're photographing at night or in other low-light situations, be aware of how the shutter speed can affect your image. When you're shooting handheld, make sure you're using a fast enough shutter speed to capture a sharp image. You'll need to hold the camera still during the entire exposure because even the slightest movement will affect the image sharpness. For example, 1/60th of a second is a good minimum shutter speed, but you might be able to get a sharp photo at 1/30th or even 1/15th, depending how steady you are. Take some test shots to find out the slowest shutter speed you can use and still have a sharp image. To use even slower shutter speeds, try bracing your body and/or camera against something, such as a wall or railing.

If you're using a tripod, there's no need to worry about camera movement (just be careful not to bump the tripod during the exposure!). When you're using a Lensbaby that can be locked in place (Composer, Control Freak/3G), image sharpness is not a problem as long as the camera stays still. If you're using the Muse/2.0/Original, long exposures are not an option if you want a sharp image. It's just not possible to hold the lens absolutely still with your fingers. Finally, don't forget about subject movement when doing long exposures. For instance, if there are people or cars moving during a one-second exposure, they'll be blurred. Sometimes these motion blurs can be used as a creative effect, such as the streaks of color from cars' headlights and taillights.

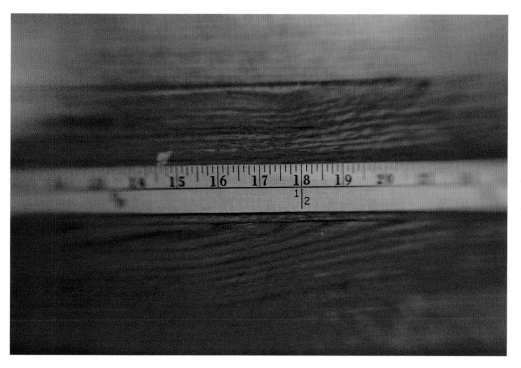

Double Glass Optic, f/4, sweet spot

The sharp area is circular in shape.

Focusing Boxes

When using autofocus with a regular lens, you might be in the habit of using the focusing boxes in your viewfinder. When you're using a Lensbaby you don't need to pay any attention to these boxes. Changing which box is selected won't affect how your Lensbaby focuses, because you're doing all the focusing manually.

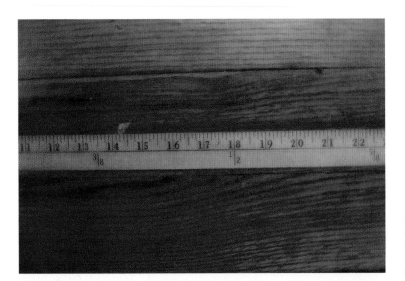

Soft Focus Optic, f/4, no sweet spot

The edges aren't quite as sharp as the center, but the image does not have the dramatic fall-off to blur created by optics with a sweet spot.

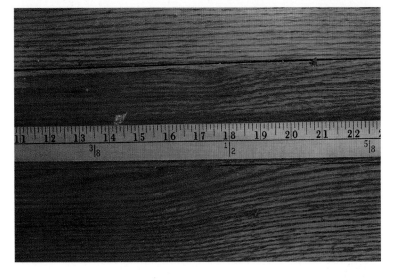

Non-Lensbaby 50 mm lens, f/4, no sweet spot

The ruler is sharp from end to end, and the area in focus is flat, extending across the entire photo.

Setting the Diopter

Accurately focusing the Lensbaby is important whether you're moving the sweet spot or not. By squeezing the lens and/or turning a focusing ring, you're manually bringing the image into focus. Therefore, it's critical that your camera's diopter is set correctly. And I can say that from experience! One time I was using the Muse and try as I might I couldn't get anything sharp in the viewfinder. The subject was close to but not quite in focus. It was driving me crazy as I tried squeezing and bending the Muse in different ways, but nothing ever came into focus. After much frustration it occurred to me to check the diopter. Sure enough, the diopter was way off. The diopter dial must have gotten turned accidentally. Once I got the diopter back to where it should have been, it was easy to bring the subject into focus.

The diopter is set for your vision; it controls how accurately you see what is in focus through the viewfinder. This means that the lens could be properly focused,

Lensbaby Composer, Double Glass Optic, f/4

Even though the sweet spot pulls the eye to the bottom half of the photo, the out-of-focus roses across the top remain graphic elements in the composition.

but if the diopter is not set correctly, the viewfinder will still look out of focus. If you were using a lens with autofocus, the camera could take care of properly focusing, even if the diopter was not set accurately. The image wouldn't look in focus to your eyes, but the camera will have properly focused the lens. The diopter adjustment is usually a slider or a wheel next to the viewfinder. Move the diopter adjustment while looking through the viewfinder. Don't worry about focusing the lens or even paying attention to what the camera is pointing at. Instead look at the black lines or boxes that are always present in your viewfinder. These may be grid lines and/or focusing boxes. Set the diopter so that these lines or boxes are as sharp as possible. If you wear glasses when photographing, have them on when you're setting the diopter. You want to set

Beginner Focusing Tips

Keep it as simple as possible in the beginning. You're trying to get used to the sweet spot and being able to tell when things are in focus. No need to try to do everything at once.

- Start with the lens straight ahead, no bending or tilting. Practice bringing the center into focus. With the Composer, use the focusing ring. For the Muse and Control Freak (and similar models), evenly squeeze the lens straight back.

- Practice focusing in bright lighting conditions. This will make it easier to see where you're focusing.
- Focus on something with lots of fine detail (newspaper, bookcase, brick wall). It might not be exciting subject matter, but with all that detail it will be easier to see when it's in focus.
- Use the f/4 or f/5.6 aperture disc so that you have enough depth of field to able to tell when something is sharp.

- Review your photos as you're practicing. Play back your photos and zoom in on them to check the focus.
- Continue to work just on bringing the center into focus until you're consistently getting sharp results. Once you're comfortable with focusing in the center, try a little bending to move the sweet spot around.

the diopter for your eyesight when you're photographing. Once the diopter is set, you can leave it alone. No need to change it unless your vision changes (or you accidentally change it, like I did). If you need more specific instructions, check your camera's manual.

Getting It Sharp (Where You Want It)

For some photos it's more critical than others to have a sharp point of focus. When working with the 2.0 or 3G or using the Double Glass optic in the current Lensbabies, the area in focus is very sharp. The viewer's eye is drawn to the sharpest part of the image, making it important to consider what you want to be in focus.

Compare the following two photos of a church steeple. Notice how placing the focus in different places significantly changes how your eye moves through the image and where it lingers.

Sometimes it can be challenging to place the sweet spot right where you want it. Here are some tips and techniques to achieve this goal.

Focusing with the Muse/2.0/Original

1. The first thing to do is focus the lens at the right distance. Begin with your subject in the center of the viewfinder, then squeeze the Lensbaby straight back (no bending) until your subject is in focus.

2. Keeping your fingers steady, recompose the picture to place your subject where you want it. The subject will now be out of focus because you've moved it away from the center.

3. Bend the lens toward the subject's location in the viewfinder. If the subject is now on the left, bend the lens to the left; if it's at the top, bend the lens up, and so on.

4. As you bend the lens toward the subject, you'll see the subject come into focus. When you bring the subject into focus by bending, you might need to fine-tune the squeeze as well. Try squeezing a touch more or less if the bending itself isn't bringing the subject into focus.

5. Once the subject is sharp, hold the lens steady (that's the job of your fingers) and gently press the shutter release button.

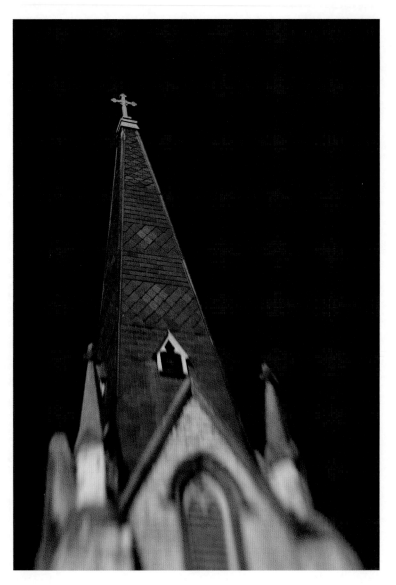

Lensbaby 2.0 (double glass), f/4

With the sweet spot on the cross, the eye is quickly
drawn to the top of the photo.

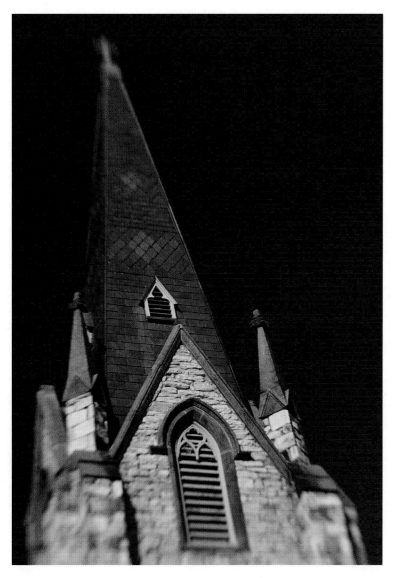

Lensbaby 2.0 (double glass), f/4

Placing the sweet spot lower keeps the attention in the central area of the image.

As you can see, the process for focusing has two main parts: squeezing and bending. If you're just getting started with a Lensbaby it can be helpful to treat these as two separate motions by squeezing first, then bending as described. As you become more comfortable with your Lensbaby, you can do the squeeze and bend in one motion to quickly focus and compose your picture.

Another element not to be overlooked is the shutter speed. This is important because whether you're handholding or using a tripod, your fingers are still what are holding the lens in place. Use too slow a shutter speed and you won't be able to keep the lens perfectly still during the exposure. Try for 1/60th of a second or faster to keep the sweet spot tack-sharp. It all depends on how steady you are. The minimum shutter speed you need to use could be slower or faster. If you end up with photos in which you're sure you got your subject in focus but the sweet spot is still blurry, you may need to use a faster shutter speed. Don't forget that a slight softness due to a subtle lack of sharpness can sometimes make for an attractive Lensbaby photo.

Focusing with the Control Freak/3G

1. The first thing to do is focus the lens at the right distance. Begin with your subject in the center of the viewfinder, then squeeze the Lensbaby straight back (no bending) until your subject is in focus.

Finger Gymnastics

Since the Muse requires you to use multiple fingers for focusing, it can be helpful to hold the camera in a slightly unconventional way. Hold the camera by putting one hand on either side, then bracing your thumbs against the back of the camera. This allows you to support the camera without gripping it with your fingers. Now your fingers are in a good position for bending the lens. For the greatest control when bending, place two fingers on either side of the lens. I use my middle and ring fingers on either side. I prefer to use the same fingers on both hands, since that way I find my brain better knows what my fingers are doing. This leaves my index finger free to press the shutter release button.

Lensbaby 2.0 (double glass), f/4

A little bit of sharpness can be enough. Here only the tiniest bit of one of the flowers is in focus, but it gives the subject just enough definition while allowing the flowers to blend into the background. The background color comes from blue tiles in a pool of water.

2. Keeping your fingers steady, recompose the picture to place your subject where you want it. The subject will now be out of focus because you've moved it away from the center.

3. Bend the lens toward the subject's location in the viewfinder. If the subject is now on the left, bend the lens to the left; if it's at the top, bend the lens up, and so on.

4. As you bend the lens toward the subject, you'll see it come into focus. When you bring the subject into focus with the bending, you might need to fine-tune the squeeze as well. Try squeezing a touch more or less if the bending itself isn't bringing the subject into focus.

5. Once the subject is sharp, lock the lens in place by pressing the button on the focusing ring. With the lens locked you don't have to worry about holding it still while taking the picture.

6. After locking the lens, you can tweak the focus by turning the fine-focus ring. Adjusting the focusing ring will change the distance at which the lens focuses. If you didn't squeeze the lens quite the right amount before locking it, the ring will let you correct this (within limits).

7. If the lens was not bent the correct amount, you can use the rods to fine-tune the angle of the lens. The rods give you the ability to adjust the angle in very small increments. To make an adjustment, turn the knobs at the ends of the rods. You can make large adjustments to the angle of the lens if you turn the rods enough, but I'd look to use them as a way to refine the point of focus, not completely change it. Get the sweet spot as close as possible before locking the lens. If you're way off from what you want, release the lens and start again.

8. The Control Freak/3G's combination of the focusing ring and the rods gives you a number of tools to nail the placement of the sweet spot. Being able to lock the lens in place gives you the option to do longer exposures. If you're handholding the camera, you'll still need a fast enough shutter speed to hold the camera still during the exposure. It's the same idea as any other time you're shooting handheld. If the camera is on a tripod, shutter speed doesn't matter in terms of capturing a steady shot, because the rods hold the lens in place. You can experiment with using long exposures and can capture sharp images as long as your subject isn't moving.

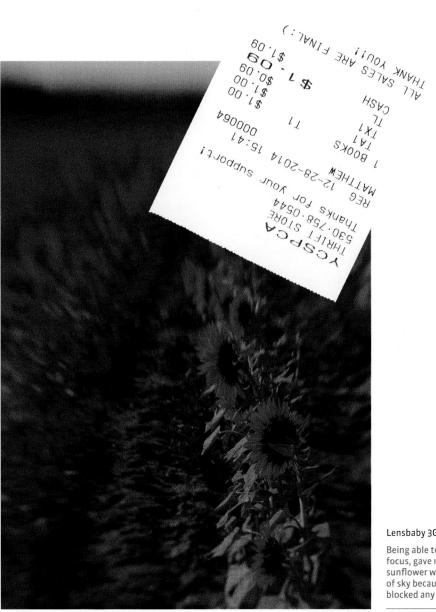

YCSPCA
THRIFT STORE
530·758·0544
Thanks for your support!

REG 12-28-2014 15:41
MATHEW
000064
 TA1 T1
1 BOOKS $1.00
 TX1 TL
 CASH $1.00
 $0.09
$ 1·09 $1.09
ALL SALES ARE FINAL:)
 THANK YOU!!

Lensbaby 3G (double glass), f/4

Being able to lock the lens in place, then fine-tune the focus, gave me the precision necessary to control which sunflower was sharp. I chose to minimize the amount of sky because the clouds and haze along the horizon blocked any color from showing through.

Careful Focusing

When you're photographing a subject with a lot of depth, such as something that begins very close to you and then extends away, take extra care in deciding where to focus. You will not get a lot of the subject in focus (also known as *shallow depth of field*) when you use a wide aperture (f/2.8, f/4, f/5.6), so make the most out of that small sharp area!

Focusing with the Composer

Focusing and moving the sweet spot with the Composer is a simpler affair. The approach is similar to using the other lenses: focus, move the sweet spot, fine-tune.

1. The first thing to do is focus the lens at the right distance. Begin with the lens straight ahead. Unlike with the Muse and the Control Freak, the lens does not "spring back" into the centered position, so you'll want to double check the position of the lens before shooting. Begin with your subject in the center of the viewfinder, then turn the focusing ring until your subject is in focus. All focusing is done with the focusing ring; there's no squeezing involved with the Composer.

2. Next, recompose the picture to place your subject where you want it. The subject will now be out of focus because you've moved it away from the center.

3. Tilt the lens toward the subject's location in the viewfinder. If the subject is now on the left, tilt the lens to the left; if it's at the top, tilt the lens up, and so on. Be careful not to accidentally turn the focusing ring while tilting the lens.

4. As you tilt the lens toward the subject, you'll see it come into focus. When you bring the subject into focus with the tilting, you might need to fine-tune the focus.

5. Once the subject is sharp, let go of the Composer and the lens will stay in place. If you need to be absolutely sure the position of the lens won't change, turn the locking ring at the base of the lens (this does not lock the focusing ring, just the angle of the lens).

6. If the lens was not tilted the correct amount, simply adjust its position and adjust the focusing ring. If you're hand-holding the camera, you'll need a fast enough shutter speed to hold the camera still during the exposure. It's the same idea as any other time you're shooting hand-held. If the camera is on a tripod, shutter speed doesn't matter in terms of capturing a steady shot. You can experiment with using long exposures and can capture sharp images as long as your subject isn't moving.

7. When you start working with the Composer it can be helpful to follow these discrete steps of focus, recompose, tilt, and refocus. As you become more comfortable with the lens, you can speed up the process by starting with the tilt, then doing the focusing. However, if the viewfinder is extremely out of focus, you might want to roughly focus so that you can at least recognize what you're looking at. Avoiding the focusing altogether would be like bending the Muse without squeezing it; odds are you'll end up with an out-of-focus mush.

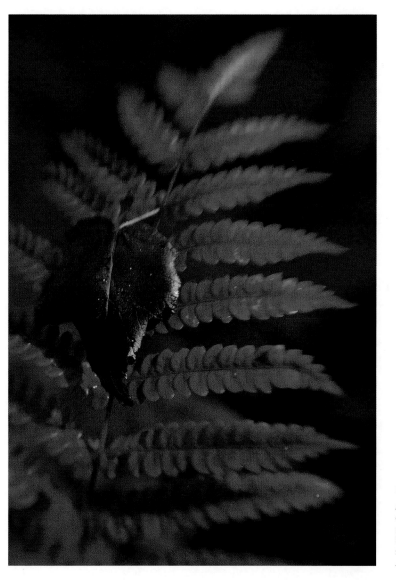

Lensbaby Composer, Double Glass Optic, f/4

As I photographed different compositions of this leaf caught on a fern, I knew I wanted the leaf to be the primary subject. When I changed the composition I would be sure to adjust the tilt of the lens and tweak the focus so that the sweet spot stayed on the leaf.

Focus Bracketing and Live View

I'll admit it: Sometimes I've used all the advice and tips I offered here, and my Lensbaby photos still aren't sharp where I thought they would be. I know it can be frustrating. If you find yourself in this situation, here are a couple ways you can better your odds.

Focus Bracketing

Focus bracketing is the idea of taking a series of pictures where the focus is changed a small amount between shots. You can use this technique whether you're handholding or using a tripod. It is most easily done with the Composer or the Control Freak/3G because of the focusing ring. Begin by setting up your shot as you normally would, then take an initial picture. Now begin the focus bracketing. Make a very slight adjustment to the focusing ring, then take another shot. I like to think of it as a nudge. Nudge the focusing ring a couple more times in the same direction, taking a photo after each nudge. Then go back to your initial point of focus and nudge the focus a few times in the opposite direction, capturing another series of pictures. What you end up with is a set of photos for which the point of focus shifts across a short distance. This gives you multiple focus options for the same shot. You better your odds that one of those photos is sharp where you want it. It might sound like an involved process, but once you get the hang of it you can do it quickly. Set up the shot, click, nudge, click, nudge, click, etc.

The key element is how small a movement you're making to the focusing ring. This technique assumes that you've got the focus pretty close at the start. These adjustments are shifting the point of focus in tiny increments around where you initially focused.

If you're using the Muse/2.0, the nudging isn't applicable. Here's what I do: Compose and focus, then take your first shot. Hold you fingers in place, then slightly relax them, letting the lens extend out until your composition falls just out of focus. Then squeeze/bend the lens to bring your subject back into focus and take another shot. Do this at least a few times to capture a set of photos with slight variations in focus. Due to the lack of precision with bending and squeezing, odds are you won't focus in the exact same spot each time. As mentioned earlier, these are small changes, not photos with completely different areas of focus.

Live View

If your digital SLR has a Live View function, it can be a big help when focusing with a Lensbaby. It'll be easiest to do this when you're using a tripod and with a Lensbaby that has a focusing ring. Compose and focus first, then switch to Live View mode. Being able to see your composition on your LCD is convenient, but to make focusing more accurate we're going to take advantage of the camera's ability to zoom into the live view. On most cameras, to zoom in you press the button that has a magnifying glass with a plus symbol on it. This is the same button that is used to zoom into a photo in playback mode.

Once you've zoomed in, navigate to where you've focused. Moving around your magnified image is usually done with a toggle button or a multi-selector pad. With the sharpest part of your composition front and center, fine-tune the focusing ring until that area is as sharp as possible. The wonderful thing about Live View is that you don't have to guess if you focused in the right place. If it's sharp in Live View, that's the spot that will be in focus when you take the picture.

Working in Live View is easiest if you're using a tripod, because you don't have to hold the camera still while using Live View and focusing. Due to the shallow depth of field you'll particularly want to pay attention to holding the camera steady. A small change in the camera's position can significantly change which part of the subject is in focus.

Using Live View while handholding is a bit more challenging. With the Control Freak/3G, your fingers are free to operate Live View, since the lens is held in place. Just watch out that when you zoom in, you keep the camera steady so that your composition stays the same. In addition, when you're zoomed in, watching your image "jump around" on the LCD can be jarring.

Photographing with the Muse (or similar Lensbaby) will offer the greatest challenges for using Live View. I would go right to Live View once you know what you want to photograph. Given that you need a couple fingers to operate Live View, it's difficult to do while using four fingers to focus plus trying to hold the camera. Once in Live View you can focus the Muse to get an idea where you want to zoom in. Release the Muse, zoom into Live View, and navigate to what you want to bring into focus (hopefully you can identify it when it's out of focus; that's one of the challenges). Go back to the Muse and bend/squeeze to bring what's on the LCD into focus. Being able to see the focusing in real time will give you an appreciation for the way even small adjustments with your fingers can change what's in focus.

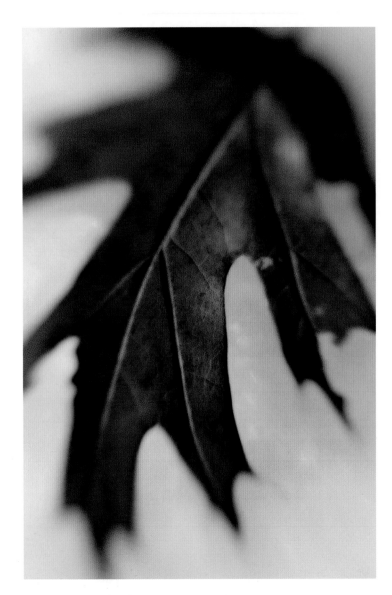

Lensbaby Composer, Single Glass Optic, f/4, +10 Macro Filter

The angle of the sun brought out the shape and texture of this tattered leaf lying in the snow. Using Live View to compose and focus made it possible to get a low-angle close-up without having to lie down in the snow myself.

Aperture Discs

Just as with a regular lens, you can change the aperture of a Lensbaby. Unlike a regular lens, there's no dial to turn or button to push on your camera body to change the aperture. With a Lensbaby, changing the aperture is a completely manual process. So, where is the aperture? Look down into your Lensbaby and you'll see a circular, washer-like object at the bottom. That's the aperture disc! With standard camera lenses there are metal blades at the back of the lens that close down to form different sized aperture openings. With a Lensbaby you choose different apertures by changing the aperture disc. Lensbabies come with the f/4 disc already inserted. So if you haven't changed the disc yet, you can assume it's f/4. The disc likely also has a "4" on it, indicating the aperture.

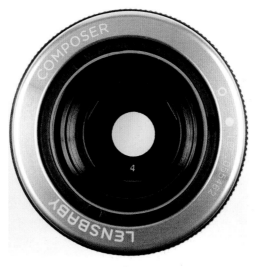

f/4 Aperture Disc Inserted in Lens

Each lens comes with a set of aperture discs. With the Muse you get f/2.8, f/4, f/5.6, and f/8. The Composer and Control Freak include f/2.8, f/4, f/5.6, f/8, f/11, f/16, and f/22.

Blur vs. Depth of Field

Using a smaller aperture will increase how much of the photo is in focus (depth of field). This can make it easier to place the sharp area in the correct spot. The downside is that as you increase the amount of area in focus, you decrease the amount of blur. More about aperture in the next section.

Live View Problem Solving

Now say that you're in Live View, but the area you want to be sharp still won't come into focus. First, make sure you're not too close to your subject (minimum focusing distance is about 18 inches with no attachments). If it's not an issue with the distance to the subject, the problem is likely with the angle of the lens. The lens may not be tilted/bent at the right position for your subject's location in the composition. Zoom back out to see the whole image in Live View, or turn off Live View to use the viewfinder, then adjust the angle of the lens. After repositioning, zoom back in on the live view to fine-tune the focus.

Disc Tip

Other than you being able to see the number of the aperture, it doesn't matter which side of the aperture disc is facing up.

Changing the Aperture

For changing the aperture, your Lensbaby came with a combination aperture tool/holder (pictured on the following page).

Pop the gray cap off and you'll see a pile of aperture discs, each labeled with its aperture number. At the opposite end of this unusual-looking object is the tool for swapping aperture discs. Pull off the black cap (which conveniently stays attached) to reveal a magnet at the end of the tool. Touch the magnet to the aperture disc in your Lensbaby and lift it out. To put in another aperture, simply pick it up with your fingers and drop it in the lens. No tool needed. More often than not the magnets will grab the disc, moving it into the correct position. If that doesn't happen, a gentle nudge of the finger will get an askew disc seated properly. You could use the magnetic tool to insert a disc, but it often becomes a hassle when you try to get the tool to let go of the disc.

Going Tool-less

If you're feeling really comfortable with your Lensbaby, you can try changing the aperture disc with just your fingers. Why do this when you've got the handy aperture tool right next to the discs? Maybe you're looking for a challenge. No, seriously, here's a real-world example: I'm out photographing and I want to change optics. If I don't have a second set of apertures (all optics don't come with their own set of aperture discs), I need to switch the aperture disc to the other optic. Maybe I'm in a rush to swap optics; perhaps I'm feeling lazy or I simply didn't bring the tool because I didn't plan on changing apertures. I'll admit to all three at one time or another. I don't do this trick often, but it's good to know it when you need it! A word of warning: The optic is right below the aperture disc, so be careful not to poke the optic and potentially scratch it.

Removing Aperture Discs

Sometimes taking an aperture disc out works like a charm; other times the magnet at the end of the tool doesn't seem quite strong enough to pull the disc away from the magnets holding it in place. I've had the disc lift part of the way up, then the tool slide off before you get it free from the other magnets. If this happens to you, try this:

1. Lift the disc out slowly.
2. Grab a different part of the disc.
3. If you get the disc partially lifted, use two fingers on your other hand to pull it out.

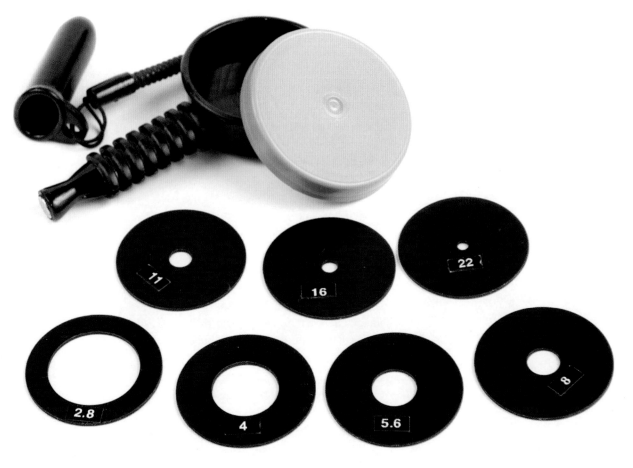

Aperture tool/holder

It's easiest to take out the f/2.8 and f/4 discs because they have a large opening (these are also the apertures I use most often because I like the softer look). It takes a little finger gymnastics; small fingers and a bit of fingernail also make this more likely to work:

Method 1. Place one finger into the Lensbaby and catch your fingernail on the inner edge of the bottom of the disc. Using your fingernail, pull your fingertip toward the side of the lens. The far side of the disc will lift up. Grab the raised disc edge with your other hand and lift it out.

Method 2. You'll definitely need at least a little fingernail for this. Slide your fingernail into the (very small) gap between the outer edge of the disc and the wall of the lens. Then use your fingernail to lift the disc up. Once it's high enough, use a couple other fingers on the same hand to grab the disc.

Image Softness and Depth of Field

Despite the Lensbaby having a whole different way to change apertures, they still control the same thing in your pictures: how much of your subject is in focus (depth of field). Although the in-focus and out-of-focus areas of a Lensbaby photo look different from those of a regular lens, the principle of apertures still applies. With a wider aperture (f/4), you have less in focus; with a smaller aperture (f/16), you have more in focus. This isn't a tutorial on depth of field but rather a look at how aperture affects the Lensbaby look. You know "the look": a small circular sharp area that quickly shifts to a strong blur throughout the rest of the image. When you use a smaller aperture, the circle of the sweet spot expands, bringing more of your subject into focus.

If you go to too small an aperture, you can lose this look. I personally use f/4 the most. I find it offers a nice balance between sharpness and blur. If you're using the Double Glass Optic, f/4 will give you a tack-sharp sweet spot; at the same time you still have significant blurring. Times when I'm looking for a softer appearance, I'll switch to f/2.8 or no aperture disc at all. I've found that by f/11 (sometimes f/8), the look has clearly faded. Sure, it's a bit soft around the edges, but the blurring does not stand out as with wider apertures. A photo begins to look less like it was taken with a Lensbaby. An exception is macro photography; for more on macro and apertures, see the Macro Kit section in Chapter 4.

Compare the following examples taken at f/2.8, f/5.6, f/11, and f/22. At f/11 things are moderately distinct, more so at f/22. I've included a set with the Double Glass Optic and the Plastic Optic to show that even a really soft optic like the Plastic doesn't retain that softness at f/11 and f/22.

Go Extra Soft

For a very soft image (one that doesn't have a lot in focus), try using your Lensbaby without any aperture disc. This is equivalent to f/2 for most optics/lenses (there is no f/2 aperture disc).

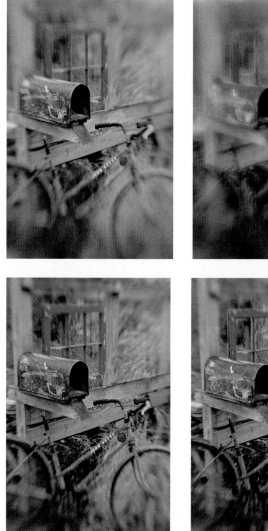

Top Left: Double Glass Optic, f/2.8

Top Right: Plastic Optic, f/2.8

Bottom Left: Double Glass Optic, f/5.6

Bottom Right: Plastic Optic, f/5.6

Top Left: Double Glass Optic, f/11

Top Right: Plastic Optic, f/11

Bottom Left: Double Glass Optic, f/22

Bottom Right: Plastic Optic, f/22

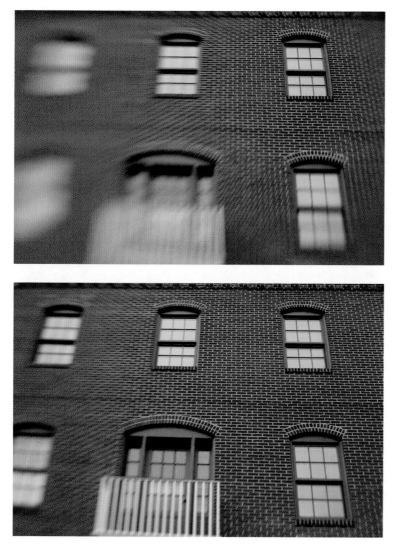

f/4 (Double Glass Optic)

f/16 (Double Glass Optic)

If you bend the lens, shifting the point of focus toward one of the sides or corners, the area opposite the sweet spot will retain some softness, even at smaller apertures. For the two photos on the previous page, the only thing that changed was the aperture. I focused on the top right window. The heavy blurring is gone in the f/16 image, but the left third of the photo is still a bit soft. That softness would not be there if I had focused on the center window.

Viewfinder Brightness

One thing that is different from changing the aperture of a standard SLR lens is that the viewfinder will become darker when you use smaller apertures. With an SLR camera, the light comes into the lens, goes through the aperture opening, and is then bounced up into the viewfinder. The size of the aperture opening affects the brightness of the viewfinder. The smaller the hole in the aperture disc, the smaller the amount of light that can reach the viewfinder. For example, with the tiny hole in the f/22 aperture disc, only a trickle of light is coming into the viewfinder. This means that your viewfinder will be dim when you're trying to compose your shot, especially if you're not shooting in bright

light. You'll definitely notice this if you use the Pinhole/Zone Plate Optic, since those settings have apertures of f/177 and f/19, respectively (more about this optic in Chapter 3).

This is not an issue with standard SLR lenses because they have an automatic diaphragm. This is a mechanism that keeps the aperture at its widest opening until you press the shutter release button to take a photo. By keeping the lens wide open, the most light is let into the viewfinder. This means that even if your aperture is set to f/22, the camera does not actually close down to the small f/22 aperture opening until you take the photo. While you're composing and focusing, the aperture opening is the same as the widest aperture of your lens (f/2.8, f/4, etc).

When you use a smaller aperture disc such as f/16 or f/22 and your subject looks dark in the viewfinder, don't be fooled into thinking that your photo will turn out dark. The darkness or lightness of your exposure is still controlled by your shutter speed. If you're shooting in an Aperture Priority mode, your camera will adjust your shutter speed as you change aperture discs. If you're working in Manual exposure, be sure to change the

Problem: The viewfinder is too dark to accurately focus when using a small aperture disc.

Solution: Use a larger aperture disc, such as f/5.6, when focusing then switch to the smaller disc to take the photo. This is most easily done if you're working from a tripod.

shutter speed after you switch discs, to maintain correct exposures.

The good news about having dedicated aperture discs instead of an automatic diaphragm is that what you see is what you get. What you see as sharp, distinct, or blurred in the viewfinder will look the same way in the final image. With an auto diaphragm lens, your only way to see in advance what will or won't be in focus is to use a depth of field preview button (not available on all cameras).

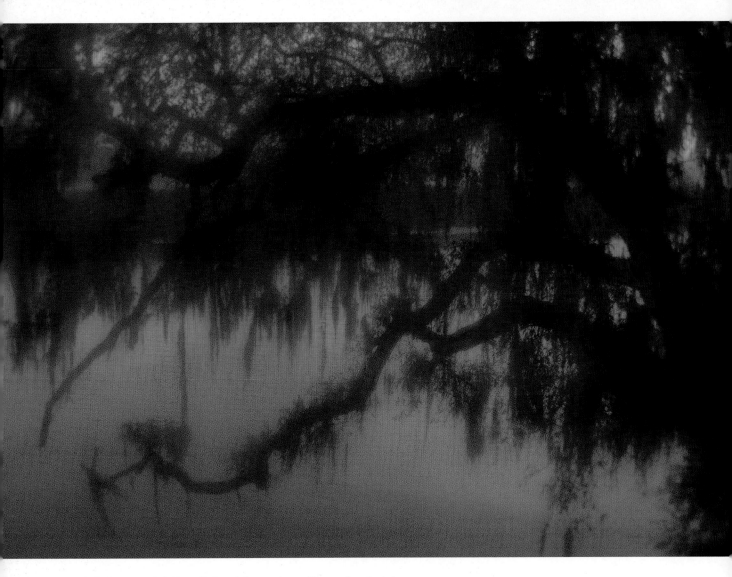

Lensbaby Composer, Soft Focus Optic, soft focus aperture disc – small center hole

Even with layers of fog softening the rising sun, the sky was still incredibly bright behind the branches of the live oak. To capture the warm glow of the sky along with detail in the dark branches I shot five exposures, one stop apart, and combined them into an HDR image. Using the Soft Focus Optic the composition became more about strong lines and color than the fine detail of the branches and Spanish moss.

PORTRAIT

portfolios

WEDDING

Peggy Dyer

Kevin Kubota

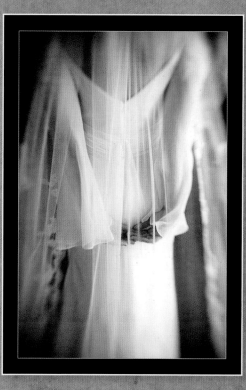

Portrait

Peggy Dyer

My philosophy is taken a bit from Wabi-Sabi, the Japanese view of life that finds beauty in all things. As an artist, it's my job to see the world differently. I'm always looking through the world for the interesting angles, using edges and available light. Finding invisible moments, and breathing them to life. I love people. I love watching them, making them smile, and capturing their personalities, their ebullience, and their essence in a way in which they might never have seen themselves before.

EMOTION, ART, ACTION – When I look through my camera, I am concentrating on what I'm feeling. I'm taking in all the colors, sounds, and the direction of the light. I want my audience to CONNECT with the image and how it makes them FEEL. I love to anticipate the position of my subject and will often track (pan) along with their motions.

DESTINATION/LOCATION – Producing beautiful scenic images that capture the majesty and mood of the location is KEY. Lensbabies make this job easy. In the style of the great Impressionist painters, I simply look for the best views of the site and think about the time of day that the light will be the sweetest. I prefer natural light and unstaged spaces where life becomes the background. I prefer my lenses wiggly, colorful, and somewhat blinded by the light, which is why I love my Lensbabies as much as the babies I'm honored to photograph. The Lensbaby captures such a dreamy moment; it allows me to guide the viewer through the composition by focusing on the sweet spot.

PLAYTIME – The most key element to capturing great art portraits for me is to allow time to connect. I surround myself with families; I go on play dates with my friend's children. I get right down on the floor and play with the kids, we draw pictures with crayons, we sing songs. It's a crucial piece to developing trust with them. Suddenly, instead of posing or flashing a fake smile, they relax, and that's when the magic begins. Kids are one of my favorite subjects because of their boundless energy and color and imaginations. I love trying to anticipate where the little girl is going to twirl, and race her there.

Before the click of the shutter, life spreads a deep tapestry of color at our feet each day. My work is vibrant and alive with all the emotion of family that I grew up loving. I weave this colorful tapestry of life into art collections, books, and canvases you can touch and say, "I remember when …," because it's these memories that are rich and precious in this banquet of life.

To see more of Peggy Dyer's photography, visit peggydyer.com

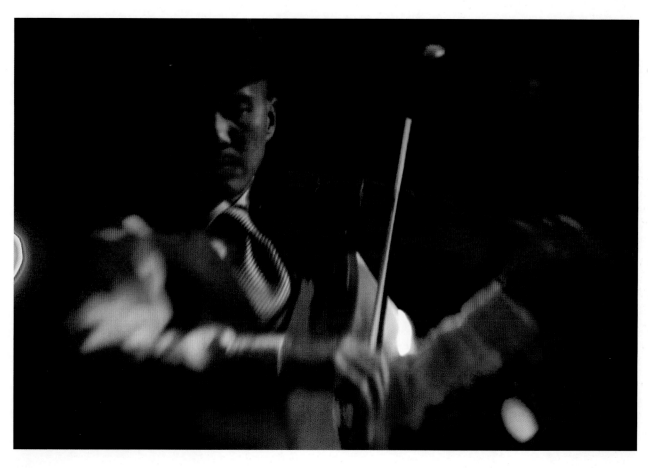

© Peggy Dyer
Lensbaby 2.0 (double glass), f/2 (no aperture disc), Telephoto Lens

Live music is a great Lensbaby subject. The colors and light shapes all over the stage let you find fun new ways to show the "feeling" of the performance. This is Kailin Yong during a performance on May 1, 2009. His style is rich and vibrant and this image captures that perfectly.

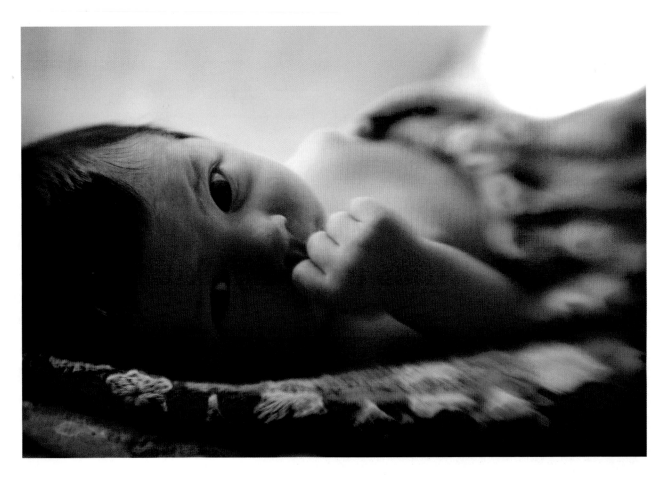

© **Peggy Dyer**
Lensbaby 2.0 (double glass), f/4

This is Ciara at two weeks old. Lensbabies + babies = awesome photos. I've always been drawn to a baby's eyes. With Ciara, it was her eyes and her hair! She has more hair than me!

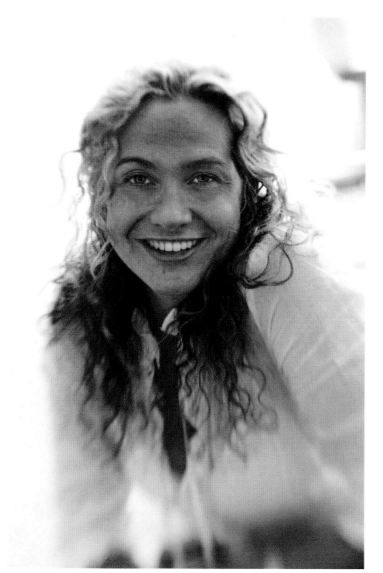

© **Peggy Dyer**
Lensbaby 2.0 (double glass), f/4

Backlit by the morning sun, she is sitting on a staircase. This image encapsulates my shooting style: natural light, casual posing, and a simple color palette, complimented with the softness of the moment and her blue eyes. Sally has a warm and inviting personality that shines through so well in this image. "Peggy Dyer is an upside-down, over-the-shoulder, alli-ooop and swish photographer. She's a joyous being who takes her subjects out from behind their own shadows by being naked, vulnerable, and human herself and in so doing, takes superhero shots capturing the soul's transit through the human form."

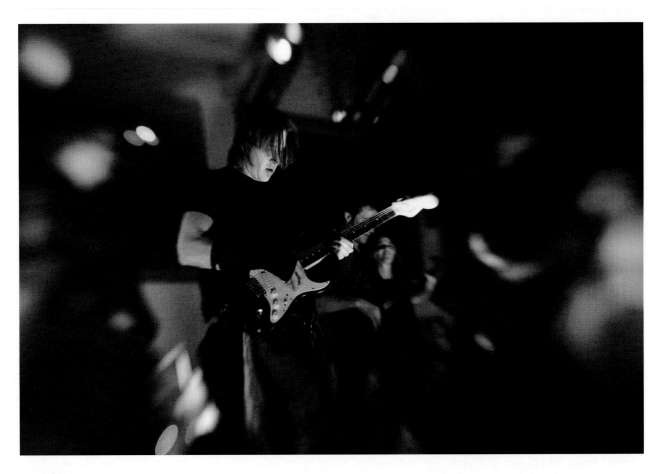

© **Peggy Dyer**
Lensbaby Composer, Double Glass Optic, f/4, Wide Angle Lens

With about a dozen musicians on stage, Seth explores his ripping guitar solo. Digital sensors are particularly sensitive to the color spectrum. The intensity of the light was consistent, but the color temperatures were causing radical shifts in my perceived detail. I found reprieve in black and white, which adds to the earthy rock-and-roll style Something Underground is known for.

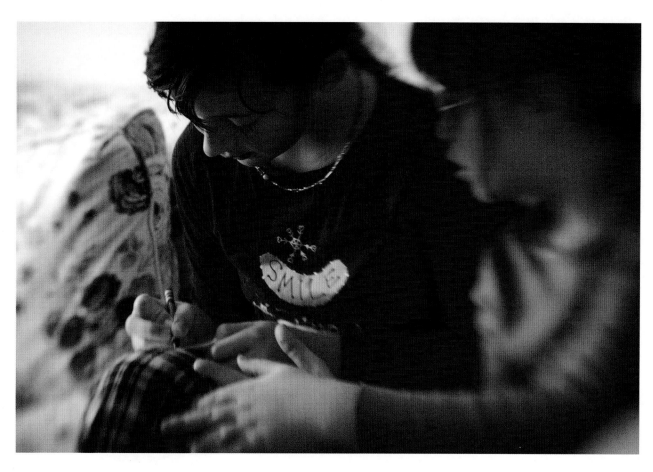

© **Peggy Dyer**
Lensbaby 2.0 (double glass), f/4

I love the color in this image. The kids were making Valentines, wearing their jammies and huddled around the living room floor. When I took this picture, the girls were writing lyrics to a song they wanted to sing for me.

Kevin Kubota

I've been photographing weddings as the focus of my business for nearly 20 years. Over the years, there have been only a few milestones that have significantly changed the way I photograph or approach a scene. The first was the switch from medium format to 35 mm format. The next was converting to digital cameras and discovering what could be done in post-processing. The last was the discovery of the Lensbaby. I think that having a tool like the Lensbaby has really helped me to look at things differently and, more important, accept those variations as a complement to what I was already doing. I think that any photographic accessory or process should encourage you to step out of your comfort zone a little. When you find yourself looking at the world and thinking, "That would be a great Lensbaby shot," then you realize you've stumbled on a paradigm-shifting photographic tool.

I love weddings because I love the spontaneity of the event. I actually enjoy working under pressure and the ensuing intuitive thought process that must accompany it to ensure success. I also love the romance, the elegance, the emotion, the intimacy of a wedding. To many women, the wedding day is a day about dreams. They have dreamed about the fantasy of it for years, they have dreamed about how this day will unfold. I love to be able to create images that capture the dreamlike images they have had in their minds. The Lensbaby has really been a perfect tool in that regard.

I generally use my Lensbaby on every wedding. Sometimes I'll use it more, sometimes less. Sometimes I even forget I have it and then think, "Darn! I should have shot that with my Lensbaby!" I currently use the Composer because of its ease of use. I also love to add the wide-angle adapter and, occasionally, the shaped creative aperture discs. I also have the fisheye and telephoto add-ons and have began to incorporate them into my images as well. I seem to be really stuck on the F4 aperture, for some reason. I love the balance of ease of focus, gentle edge diffusion, and brightness for viewing.

Photographing weddings has been a tremendous creative outlet for me, visually and emotionally. I live vicariously through the images I capture and the scenes I help to create with my clients. I think that my vision and emotion work well with the dream they've been building and evolving for years.

To see more of Kevin Kubota's photography, visit kevinkubota.com

© **Kevin Kubota**
Lensbaby Composer, Double Glass Optic, f/4, Wide Angle Lens

The Composer worked really well to diffuse the hard lines of the car and potentially distracting details on the ground around the car. I added light, dark, vignette, and color enhancing in Photoshop with my actions.

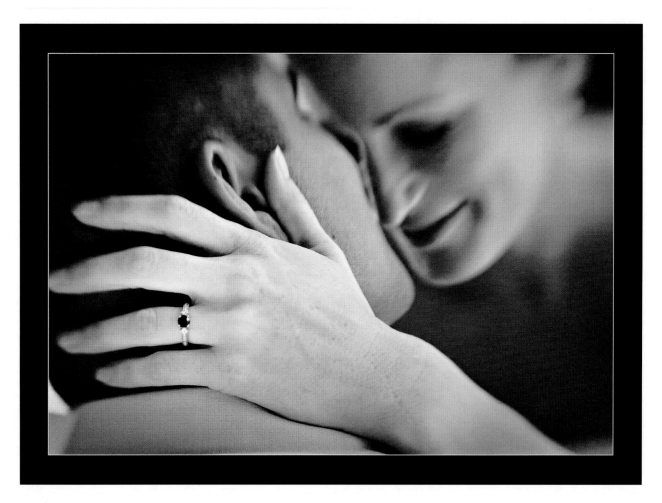

© **Kevin Kubota**
Lensbaby Composer, Double Glass Optic, f/4

A fresh way to photograph a ring: keeping an emotional element as the background, diffused by the Lensbaby.

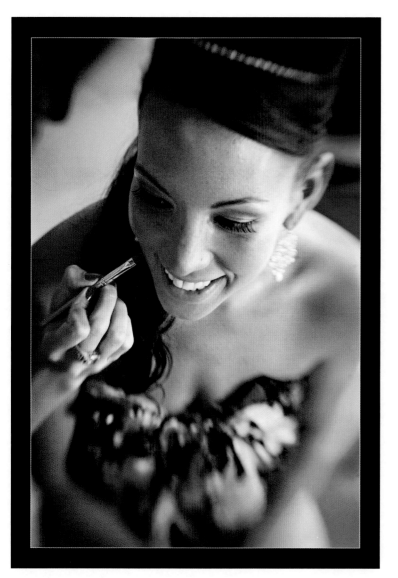

© **Kevin Kubota**
Lensbaby Composer, Double Glass Optic, f/4

Perfect sharpness where it's needed, and softness where it's needed as well. The ability to selectively blur parts of an image is very valuable when you have "sensitive" areas that you really don't want too visible. Natural light.

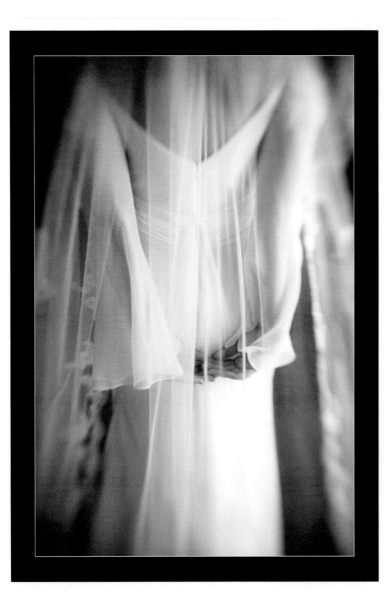

© **Kevin Kubota**
Lensbaby Composer, Double Glass Optic, f/4

The Composer allows for very quick and spontaneous capture, with its intuitive hot spot and focus ability. I saw this image while the bride was dressing and loved how the LB softened all the lines of the veil to create a dreamlike and somewhat abstract image. Making it B&W further draws attention to lines, shapes, and texture.

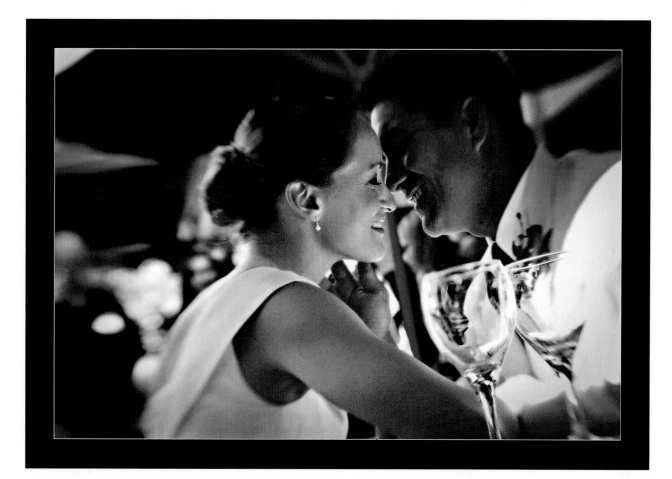

© **Kevin Kubota**
Lensbaby Composer, Double Glass Optic, f/4

When a very sensitive and intimate moment presents itself, you want to capture the expression and draw the viewer's attention to the aspects of the photo that create that intimate feeling. When too much is in focus or recognizable, the mind tends to settle these areas or analyze them. It's better to keep them abstract or vague so the viewer can appreciate the emotional details. Light was natural and bounced from a 45" diffuser disc. Additional fill light was provided by my Digital Fill Flash action.

OPTICS

The Optic Swap System

The Optic Swap System was introduced with the Composer, the Control Freak, and the Muse. What does it do? It allows you to change, or swap, the glass inside the lens. This further opens up the Lensbaby's creative possibilities. It moves us beyond just bending the lens for effect. Now we have lots of options: create a soft-focus look, shoot with plastic instead of glass, have a pinhole camera, capture an incredibly wide fisheye view—and more!

The Basics

- Your Lensbaby comes with one optic already "installed." For the Composer and Control Freak, it's the Double Glass Optic. The Muse can be purchased with either the Double Glass or the Plastic Optic.

- Additional optics are available individually. There's also an optic kit that includes the Single Glass, Plastic, and Pinhole/Zone Plate Optics. It saves you a little money over buying the optics individually.

- Most optics are made up of one or more pieces of glass, which are called *elements*.

- A few of the optics have a color coded stripe circling the top, making it easy to look at the front of your lens and know which optic you're using—at least as soon as you memorize which colors are which. That took me a little while! No worries if you don't memorize the colors; around the base of the optic is another colored strip that has the optic's name on it.

- The optics come in a hard plastic container. The top of the container doubles as a tool for inserting and removing optics.

- The Optic Swap System cannot be used with the Original, 2.0, or 3G Lensbabies.

- Optics that are not as sharp will produce images that have less contrast.

Optic container

Swapping Optics

The top of the containers for the optics is also the tool for inserting and removing optics. The bottom of the lid has three posts that fit into the notches along the top edge of the optics. With the posts in place, press down, then turn the lid counterclockwise to release the optic. Make sure you press down before turning; otherwise the optic won't rotate. The top of the lid has arrows on it showing you which way to turn.

On the front edge of each lens there is an open circle and a closed (solid) circle. Notice that one of the notches in the optic lines up

Optics Quick Look

- Double Glass: Sharpest, sweet spot
- Single Glass: A little soft, sweet spot
- Plastic: Very soft, sweet spot
- Pinhole/Zone Plate: Soft and equally "sharp" across the image, no sweet spot
- Soft Focus: Sharpness with a soft glow, no sweet spot
- Fisheye: Fisheye distortion, no sweet spot

Lensbabies Past and Present

You might be wondering how the current optics compare to the glass used in the previous Lensbaby models.

- The Original Lensbaby had the equivalent of a single glass optic (f/2.8 maximum aperture).
- The Lensbaby 2.0 and 3G both had double glass optics (f/2 maximum aperture).

with one of the circles when it's seated in the lens. The notch points to the closed circle when it's locked and the open circle when it's released. These are also a reminder of which way to turn to lock the optic and which way to release it.

Lift the optic out and drop the new one in. Use the tool to lock the new optic in place. Line up the posts and turn clockwise. Be aware that when no optic is in the lens, it's almost like not having a lens on the camera. The lens just holds the optic in place, so without the optic you can look right through the lens and see the mirror in your camera. Have your next optic ready to insert, to minimize the amount of time the inside of the camera is exposed.

Swapping Tips

For the Composer and Control Freak, first turn the focusing ring so that the optic is raised flush with the top of the lens. If the optic is recessed too far, the posts on the tool won't be able to reach it.

When you're using the Composer, most of the time the optic will easily release, but for times when it doesn't, try the following: If the

optic appears to be turning but doesn't release, this means that the ball and socket connection is turning, which spins the optic around. To help avoid this, get a good grip on the Composer, either around the focusing ring or at the gap between the focusing ring and the base. When gripping the focusing ring, have part of your thumb touching the top of the Composer to keep the focusing ring from accidentally turning (place your thumb on the edge where the ring meets the top of the lens). If it's still not working, tighten the locking ring at the base of the Composer.

After fitting the optic in the lens, you can also try using your fingers to lock it into place. With the Muse you can grip the outer edge of the optic and turn it clockwise until it locks into place. For a better grip, put a fingernail in one of the holes. For the Composer and Control Freak, fingers or fingernails also work. Place two fingers on opposite sides of the top edge of the optic. Then press down with your fingers and turn the optic and lock it. Alternatively, you can place two fingernails in two of the holes, then rotate the optic until it locks into place.

Optic Comparison

Double Glass Optic, f/4

Single Glass Optic, f/4

Plastic Optic, f/4

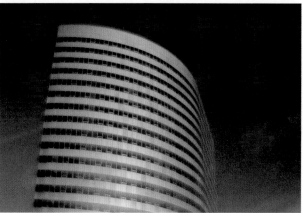

Soft Focus Optic, f/4

Zone Plate Optic

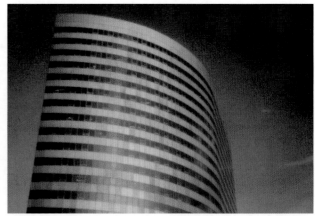

Pinhole Optic

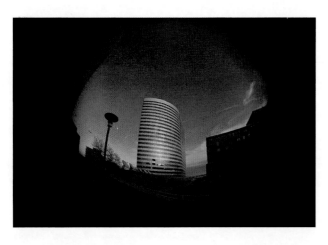

Fisheye Optic, f/4

Double Glass Optic
Specs

Coating: Multi-coated

Material: Glass, two elements

Aperture: f/2 optic

Focal length: 50 mm

The Double Glass Optic is the most common optic. Odds are, if you have a Lensbaby, you've used the Double Glass. It's the standard optic for the current lenses and has also been in the previous two generations of Lensbabies. It's the sharpest optic due to having two multi-coated glass elements. The sweet spot will be very sharp (using f/4 or smaller). It's the optic I use the most.

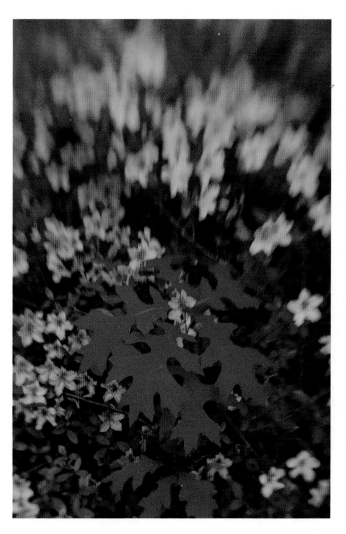

Lensbaby 3G (double glass), f/4

I used the sweet spot to draw attention to the cluster of oak leaves surrounded by azalea blossoms.

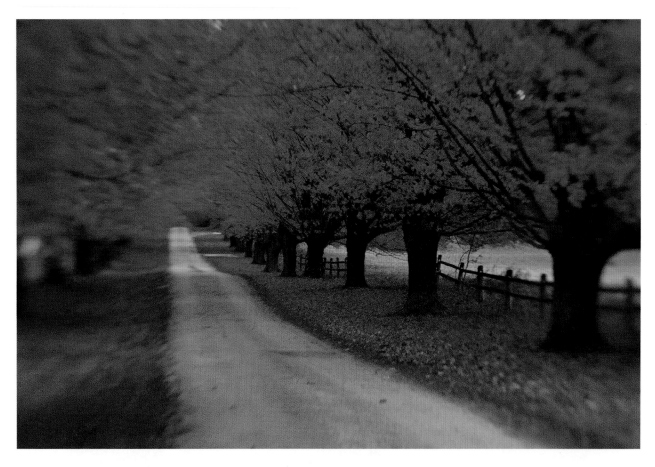

Lensbaby 2.0 (Double Glass), f/4
In addition to the road, the rows of trees and the fence also act as lines leading the eye through the scene.

Single Glass Optic
Specs

Coating: Uncoated

Material: Glass, one element

Aperture: f/2 optic

Focal length: 50 mm

Your images become a little softer with the Single Glass Optic. Since it uses one glass element instead of two, the sweet spot isn't quite as sharp as the Double Glass. The Single Glass is similar to what was in the Original Lensbaby. Your photos will have a soft, dreamy look to them. Since the optic is uncoated, it is more susceptible to flare and chromatic aberration. You can use this to your advantage by using this optic when you want to capture flare effects in your images. Try shooting toward the sun or another strong light source to produce flare. The fun part is seeing what shows up in your images.

Lensbaby Composer, Single Glass Optic, f/2 (no aperture disc)

Shooting with no aperture disc created a very soft look that allows the red leaves to blend with the cotton grass in the background.

Lensbaby Composer, Single Glass Optic, f/2 (no aperture disc), Telephoto Lens

I used the fence to frame the curious calf that was keeping an eye on me. Notice that at such a wide aperture there's an overall glow and the transition from sweet spot to blur is smooth, unlike the previous cotton grass photo, which has a more dramatic transition.

Plastic Optic
Specs

Coating: Uncoated

Material: Plastic, one element

Aperture: f/2 optic

Focal length: 50 mm

If you want a super-soft image, turn to the Plastic Optic. As you've probably guessed from the name, this optic is just plastic. Shoot with the Plastic Optic to capture ethereal images. If you thought the Single Glass gave a dreamy look, the Plastic takes it to a whole new level! Since the plastic element is uncoated, it will also easily produce flare and chromatic aberration.

Lensbaby Composer, Plastic Optic, f/4

A fisherman preparing bait for the next day. I used the back and side of the boat to frame what was happening on board. The Plastic Optic allows images to be less about sharpness and more about color, tone, and shape.

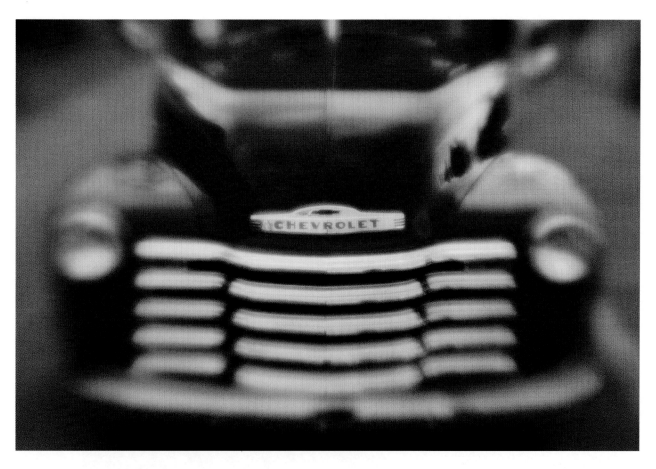

Lensbaby Composer, Plastic Optic, f/4

In addition to a wide aperture, the Plastic Optic helped soften the details of the car and the background.

Flare and Chromatic Aberration

Flare and chromatic aberration are most likely to show up when you're using an optic that has uncoated elements (Single Glass or Plastic). Flare shows up in a couple forms. It can appear as hazy circular or oval shapes floating in your image (sometimes they'll have color to them). They're often small and might be overlooked.

The second type of flare can more easily be used as a creative element in your compositions. It shows up as repeating rainbow colored lines that are curved or wavy. They can be subtle or very prominent; it just depends on how strong the flare is.

Shooting toward a bright source of light increases the chance of flare. To avoid having the light source in the photo but still capture the flare effect, compose so that the light source is right outside the edge of the viewfinder. I also find that flare is more likely to occur when you're using a wider aperture disc (or none at all). By knowing what conditions are likely to produce flare, you can work to create flare or to avoid it. Depending on the type of photo you're shooting, flare can be a bonus or an annoyance. If you want to eliminate flare, try shading the front of the lens with your hand or give the Step-up/Shade a try (more on this accessory later in the chapter).

Cropped image to show flare detail

Rainbow flare

Chromatic aberration (also known as *color fringing*) is subtler than flare. It appears as a glowing edge (often blue or purple) around elements in your photograph. It's more likely to occur along edges with high contrast (where a light tone meets a dark tone). You might need to zoom in to full size (100%) to clearly see the fringing. Chromatic aberration can be reduced or eliminated using software adjustments such as the Lens Correction Filter (Filter > Distort > Lens Correction) in Photoshop®. In addition, check out Gary Yost's photo in the Community Gallery at the end of this book for an outstanding example of using flare as a creative effect.

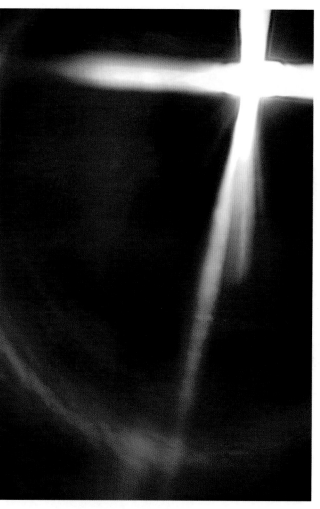

Lensbaby Composer, Plastic Optic, f/2 (no aperture disc)

While photographing shafts of light coming under a door, I found that if I was in just the right position I could create a dramatic flare effect.

Metering with the Pinhole/Zone Plate

Even if you're shooting in an Aperture Priority mode, your exposure may be anywhere from a little to way off when using the Pinhole/Zone Plate Optic. I think those tiny holes and miniscule amounts of light coming in challenge the camera to select a proper shutter speed. This is nothing serious; just be aware that you'll likely need to dial in some exposure compensation when using this optic.

Pinhole/Zone Plate Optic
Specs

Coating: N/A

Material: Litho film

Aperture: Pinhole f/177, Zone Plate f/19

Focal length: 55 mm

The Pinhole/Zone Plate Optic has no glass or plastic elements. Look into the bottom of the optic and you'll see two holes set in a slider. Move the slider back and forth to switch between Pinhole and Zone Plate. The smaller hole is the pinhole and the larger one is for the zone plate. Whichever hole is in the center of the optic is the one that's being used. Litho film covers both holes.

As noted in the specs, both have small apertures, but the Pinhole is a tiny f/177. Hold the optic, by itself, up to the light and you can better see the difference in size between these holes. The Pinhole is just a tiny point of light. The Zone Plate is noticeably larger, but take a closer look at it. It appears as though there is a very small hole in the center with a somewhat hazy area filling the rest of the zone plate opening. Grab a magnifying glass or a loupe for an even closer look and you'll see that the "hazy" area is actually a series of concentric circles. I don't know how many circles, but there are a lot of them! They're printed on the litho film. Even though the Zone Plate opening is similar in size to the hole in the f/22 aperture disc, the concentric circles (and lack of an optical element) cause it to produce a very different kind of photo.

Lensbaby Composer, Zone Plate Optic, Telephoto Lens

The Zone Plate Optic produces a pronounced glow around
light sources and light-toned elements, such as this stained
glass window and lamp.

Hidden Zoom

When you use the Pinhole/Zone Plate, the focusing mechanism can be used as a mini-zoom. If you're using the Composer, turn the focusing ring all the way to the right to "zoom in" and all the way to the left to "zoom out." For the Muse and the Control Freak, squeeze the lens all the way back to "zoom out"; don't squeeze at all to "zoom in." You're actually changing the focusing (which affects the size of things), but when the elements in your photo stay pretty much in focus at both ends of the focusing scale, you're able to use it as a zooming mechanism.

For both the Pinhole and Zone Plate there is no sweet spot, so it's not necessary to bend the lens. Your photos will be sharp across the image. Well, sharp might not be the best word; let's say distinct. Although this optic offers small apertures, neither setting will produce the sharpness of f/22 using the Double Glass Optic. But I doubt you're using a Lensbaby to try to get everything sharp from edge to edge. The Pinhole and the Zone Plate create images with an overall soft appearance. Elements in your photo won't be way out of focus, nor will they be tack-sharp. Both settings will produce a soft look, but the zone plate has a more pronounced glow, offering a dreamy appearance. The glow is more apparent around light-toned elements.

Furthermore, because of this glow I've found that the Zone Plate works best when there is moderate to high contrast and/or a variety of colors. When there is low contrast or not much variation in color, the glow can cause elements to blend together, resulting in a mushy lack of definition.

Composing Challenges

Composing can be a bit of challenge, particularly if you are photographing in less than bright lighting conditions. In Chapter 2 I discussed how using smaller aperture discs results

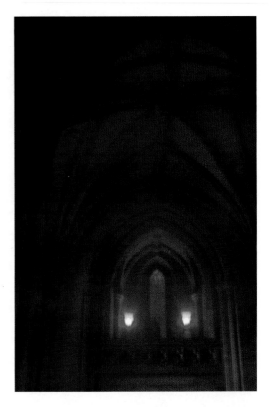

Lensbaby Composer, Pinhole Optic

The Pinhole Optic gives the inside of a cathedral a soft yet distinct appearance. The strong lines of the arches also help keep the subject well defined. In dim lighting situations you can expect very long exposures with the Pinhole. The exposure for this image was two and a half minutes at ISO 800. However, when I was taking test shots to fine-tune the composition, I used a much higher ISO. This gave me shorter exposures, so I didn't have to spend as much time waiting.

in a darker viewfinder. The same idea applies here. You have two very small holes, which are your apertures. While the Zone Plate hole is close to the size of the f/22 aperture, the viewfinder will be darker because the lines of the concentric circles block some of the light. It's still manageable to compose and focus as long as you're not working in low light. Composing with the Pinhole is more difficult because the viewfinder is so much darker. To make Pinhole composing easier, set up your shot with the optic set to Zone Plate to take advantage of the brighter viewfinder. Once you have composed your shot, switch to the Pinhole and take the picture.

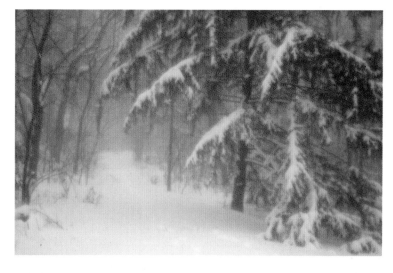

Pinhole

Pinhole vs. Zone Plate

Whether the Pinhole or the Zone Plate is the better choice can depend on the subject as well as personal taste. Let's take a look at a couple comparisons.

Snowy Scene

Both images shown here offer a soft impression of the scene. The Pinhole keeps the tree trunks and snow-covered branches more distinct. In the Zone Plate image the snow-covered path blends into the surrounding woods. I prefer the Pinhole version.

Zone Plate

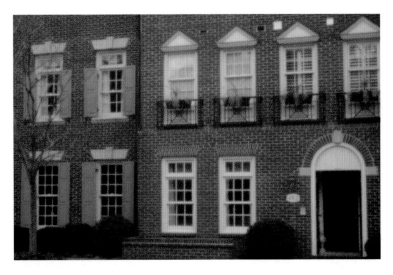

Pinhole

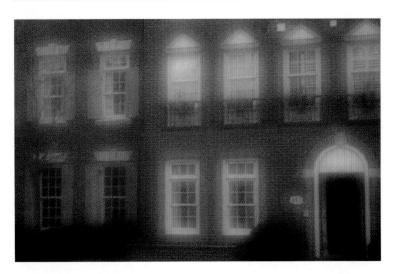

Zone Plate

Building Façade

For this image I don't find the Pinhole's softening attractive. To me it just looks like the building is a bit out of focus. Granted, all Pinhole photos are soft, but that doesn't mean all subjects will benefit from that effect. The Zone Plate image, on the other hand, has a warm, inviting glow.

Focusing is not as much of a concern with this optic. For the Pinhole's f/177 aperture, you can count on it bringing everything into focus. Turning a focusing ring or squeezing the lens isn't really going to make a difference. You might want to do a little focusing if you're using the Zone Plate, since the focus of its f/19 aperture doesn't reach as far as the Pinhole. Even if you don't focus precisely, the photo can still look good because the soft appearance of Zone Plate images hides the lack of sharpness.

Cropped image to show detail
The Pinhole made it very clear that my sensor needed to be cleaned.

Zone Plate Special Effect

Remember the concentric circles I described on the zone plate? They can create a cool special effect. If you include bright points of light in your photo, a series of concentric circles will appear around the light source. It's as though the circles on the zone plate are superimposed on your image! See the example on this page.

Sensor Spots

Have a clean sensor before you use the Pinhole/Zone Plate Optic. Spots on your sensor can be an annoyance with any type of lens, but using the Pinhole/Zone Plate will make them painfully obvious. The lack of glass in this optic actually contributes to the spots being so well defined. I think perception plays a role, too. The distinct spots stand out in contrast to the overall softness of the image, making them harder to overlook. The Pinhole more so than the Zone Plate renders them as crisp black dots because its tiny aperture causes the spots to be sharper (that is, with harder edges). If you've got a lot of them, it becomes a real headache to clean up in post-processing. See the cropped detail example on this page, which shows the sensor spots.

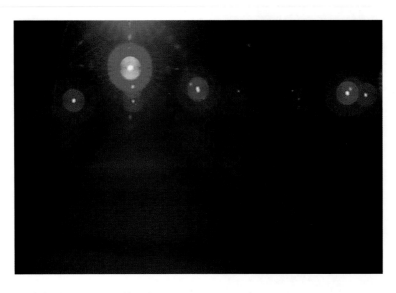

Lensbaby Composer, Zone Plate Optic

The Zone Plate Optic's special effect turned all the lights along this walkway (and in the distance) into concentric circles. The intensity and flare around the largest one makes me think of the sun.

Soft Focus Optic
Specs

Coating: Multi-coated

Material: Glass, two elements

Aperture: f/2 optic, comes with three soft focus aperture discs plus f/2.8 to f/22 regular aperture discs

Focal length: 50 mm

The Soft Focus Optic creates a soft, diffused look and can create a noticeable glow around bright elements. This optic doesn't have a sweet spot, although the center area is a little sharper than along the edges. If you bend the lens it will push more of the photo out of focus in the opposite direction of the bend. For instance, if you bend the lens to the right, the left side of the photo will be noticeably out of focus. Bending the lens only has a subtle effect on moving the area in focus. For instance, if I bend the lens to the right, I don't see a big difference in the sharpness of what's on the right side of the photo (but the left side is definitely more out of focus). If you're going to bend with the Soft Focus Optic, use it to push part of your image out of focus, not to change the sweet spot. Bending the lens can also have the benefit of drawing more attention to the area that has stayed sharp. If you're not looking for this effect, just keep the lens pointed straight ahead.

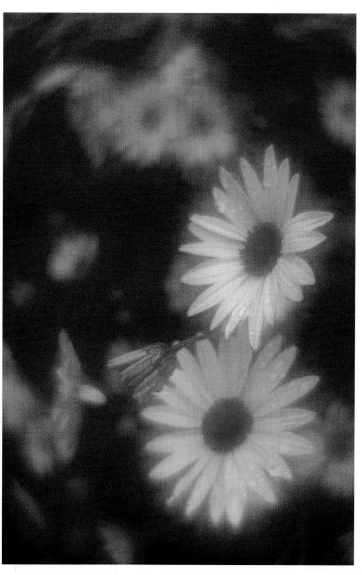

Lensbaby Composer, Soft Focus Optic, soft focus aperture disc—large center hole

Using a soft focus aperture created a glow around the foreground flowers. I used the +4 Macro Filter to get in close, but then found I wasn't able to include as many of the flowers in the background. I solved the problem by attaching the Wide Angle Lens to the Macro Filter. This let me stay in close but include more of the background.

The soft focus is created by the glass optic, but you can enhance the effect by using the special aperture discs that came with it. Because these discs have smaller holes surrounding the main aperture hole, they increase the softening effect. The larger the center hole, the softer the image. Furthermore, the softer appearance causes the photos to have less contrast. If you don't want the extra softening, you can use the regular aperture discs instead.

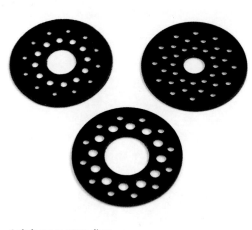

Soft focus aperture discs

Technical Specs for Soft Focus Aperture Discs

When determining the aperture for these special discs, the extra holes play a role in the effective aperture. The info below tells you the overall aperture (taking all holes into account) as well as the aperture of just the center hole:

Large center hole—all holes: f/3.3, center only: f/4.8

Medium center hole—all holes: f/4.8, center only: f/6.7

Small center hole—all holes: f/4.8, center only: f/9.5

Soft Focus Comparison

On the next page is the same scene photographed with the standard f/4 aperture and the soft focus aperture with the largest center hole.

The depth of field for the two images is about the same. The soft aperture image is a bit more hazy and has less contrast. This effect is uniform across the photo, which makes it different from the haziness of the Single Glass and Plastic Optics because of their sweet spot. See page 96 for a version with the Plastic Optic.

Soft Focus Optic, f/4 (regular aperture disc)

Soft Focus Optic, soft focus aperture disc: large center hole

Plastic Optic, f/4

The special aperture discs have noticeably different effects on a photograph's in-focus and out-of-focus areas. The softened out-of-focus backgrounds take on a slightly mottled appearance, which adds texture to the softness. As for the in-focus areas, the discs control the amount of glow, or halo, around them. The smaller the center hole, the greater the glow. Take a look at the detail comparisons of the sign.

Regular aperture: f/4

Soft focus aperture: large center hole

Soft focus aperture: medium center hole

Soft focus aperture: small center hole

To best understand the differences, take a photo of the same subject with each of the soft focus apertures (keep the focus the same for each shot). As you review them on your computer, switch from one photo to another to see the shift in softening. I find that the effect is too subtle to really appreciate if you look at the three versions side by side. You can tell they're different, but flipping between them makes the changes more apparent. For this reason I didn't include a comparison of the full images here; they'd look too much the same.

Since much of the fun of using a Lensbaby is experimenting, try combing soft focus aperture discs with regular ones. Drop in a soft focus disc, then a regular f/2.8 or f/4 disc on top of it. The regular disc will block some of the extra holes, changing where the extra softening happens. I recommended the wider regular discs because if you go to f/5.6, it will block all the small holes and you might as well use only a regular disc. How many and which holes the f/2.8 or f/4 discs will cover up depend on the soft focus aperture they're combined with. Try mixing and matching the discs when they're not in the lens. This makes it easy to see what holes will be covered up.

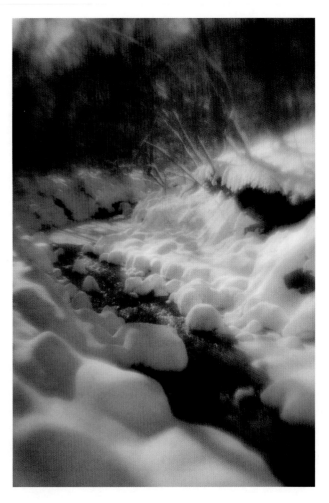

Lensbaby Composer, Soft Focus Optic, soft focus aperture disc: medium center hole

The softening effect helped reduce the contrast of the scene and smooth out details in the snow, improving its appearance under unflattering midday light.

Aperture Disc Special Effect

There's another special effect you can create with the soft focus aperture discs. Any bright point of light, whether it's an actual light source or the reflection of one (a specular highlight), will take on a starburst pattern. This can occur with both in-focus and out-of-focus points of light, but if the light is out of focus the burst will be larger. These effects also remind me of mini-fireworks, especially if you have a light source that's not white. The size of the pattern varies with the disc used. The disc with the largest center hole creates the most expansive burst. The medium and small center holes create bursts that are smaller and more distinct (not as soft). These two bursts are about the same size, but their patterns are a little different. You'll be able to see this effect in the viewfinder, which can help you decide which aperture disc to use. The effect is similar in concept to using the Creative Aperture Kit (more on that later in the chapter).

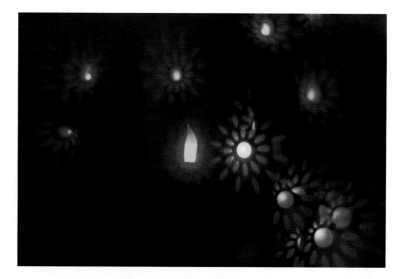

Lensbaby Composer, Soft Focus Optic, soft focus aperture disc: large center hole

Using a soft focus aperture disc caused the out-of-focus candle flames to turn into burst patterns.

Live View for Checking Vignette

If your camera has an APS size sensor, you will not see all the Fisheye's vignetting in the viewfinder unless your viewfinder has a 100% view (not common for cameras with this sensor size). This can make it challenging when you're trying to center the vignette so it's the same in all four corners. To get an accurate view of the vignetting use Live View, which shows you exactly what will be included in the photo.

Fisheye Optic
Specs

Coating: Multi-coated

Material: Glass, six elements

Aperture: f/4 optic, comes with f/5.6 to f/22 aperture discs

Focal length: 12 mm

The Fisheye Optic gives you a very wide view of the world with its 12 mm focal length plus the circular distortion unique to fisheye lenses. You can also get really close to your subject since the Fisheye focuses down to one inch. There isn't a sweet spot with this optic, so there's no need to bend the lens. Even with the extremely wide angle of view, using a wide aperture still produces a shallow depth of field, especially for close-ups. However, since the Fisheye doesn't have a sweet spot of focus, there is no quick, dramatic shift to out-of-focus blur that you see with the Double Glass, Single Glass, and Plastic Optics. If you are working really close to your subject, try shooting in Live View mode to make composing and focusing easier. If you have to look through the viewfinder while being close to your subject, you could easily cast an unwanted shadow over your subject. Live View allows you to keep the camera at arm's length, helping you avoid blocking the light on your subject. You can fine-tune the focus as you watch the image in Live View. If you'd prefer not to adjust the focus with the lens, you could instead move the camera forward and back until the image is sharp where you want it. If your subject is close to the ground, Live View also helps you avoid having to sit or lie down to get the shot.

Lensbaby Composer, 12 mm Fisheye Optic, f/4

I placed the lens as close as possible to these mums, taking advantage of the Fisheye's close focusing capability. Using Live View made it easier to line up the best composition; I didn't have to be flat on the ground, peering through the viewfinder. It was fun to watch the distortion's effect on the flowers. It looked like there was a red and green marble rolling around on my LCD screen!

Upside Down for a Good Fit

When the Fisheye is stored in the plastic container, it must go in upside down (small end up); otherwise the container's top will not fit.

The design of the Fisheye Optic is different from the rest of the optics; it's taller and heavier, and the glass elements come right up to the top of the optic. Because the glass is so close to the edge, you can't use the standard lens cap. The Fisheye is designed for use with the Composer. A special adapter is needed to use it with the Muse and the Control Freak (available on the Lensbaby website). Without the adapter, the optic won't be able to lock into place. Furthermore, the optic has a limitation when it's used with the Control Freak. Unless you're focusing super-close (less than a few inches away), the balls at the ends of the rods will be visible at the edge of your photo.

What might not be initially apparent is that there are two pieces to the optic. The top of the optic unscrews to remove the optic's core. Turn the upper part of the optic, which has the lettering on it. With the center removed, the Fisheye begins to look more like the other optics. It's the most advanced optic in that it has six glass elements, which are split between the optic's core and its base. You'll only need to remove the core if you want to change the aperture.

Fisheye Apertures

The Fisheye does not come with an aperture disc inserted. Without a disc the aperture is equivalent to f/4 (unlike most of the other optics, which are f/2 without a disc). It comes with a set of aperture discs designed specifically for the Fisheye, ranging from f/5.6 to f/22. To help avoid mixing Fisheye apertures with regular apertures, the discs are labeled with "FE" for Fisheye. Place a Fisheye f/5.6 disc next to a regular f/5.6 disc and you'll see that the size of the holes is different. The Fisheye aperture openings are one stop smaller than the regular apertures. This means that a Fisheye f/5.6 is the same size as a regular f/8. If an f/4 or f/2.8 disc were used, it would make no difference because they don't cover up any of the glass at the base of the optic. It would be as though they weren't even there.

The Fisheye Optic comes with the standard aperture tool, but you don't really need to use it. To insert an aperture disc, just drop it into the optic. Removing a disc is easier because there are no magnets holding it in place. All you need to do is turn the optic upside down and the disc will fall out. If it doesn't come out right away, tap the optic lightly in your hand.

© **Craig Strong**
strongphoto.com
Lensbaby Composer, 12 mm Fisheye Optic, f/16

I took this image with my camera sitting on the rocks in front of a long tidal pool on a rocky beach on Orcas Island. Shooting ISO 2000 at f/16 allowed me to bring the majority of this image in focus, with a fast enough shutter speed to stop most of the small wave coming over the edge of the pool toward the camera.

Crop the Black

If you're using a full-frame camera, you might want to try cropping off some of the black, especially if you're not getting any of the colored flare. Cropping to an almost square format fits the Fisheye sphere nicely.

Working with the Black Border

You'll see there's some black around the edges of your Fisheye photos. That's because the end of the optic is extending into the picture space. How much black is visible depends on the camera's sensor size. For cameras with smaller sensors, there is a little black along the left and right sides (for horizontal photos) and in the corners. When you look through the viewfinder, you can see a haziness in these areas. For full-frame cameras, there is lots of black to the left and right (horizontal orientation). Your photos will almost be a full circle surrounded by black; just a little will be cut off at the top and bottom if the lens is pointed straight ahead.

Since there isn't a sweet spot, you don't need to bend the lens for focusing reasons. But bending can offer more creative options

and allows you to control where the black border appears. For APS sensors, try bending the lens left or right to remove the black border on one side. This will increase the amount of black on the other. For more fun, bend the lens up or down to bring the optic into the photo at the top or bottom. A curved black border at the top creates an arch-like effect. If you're using a full-frame camera, you can also bend to the left or right, but with a larger shift required this might not be as desirable. Bending up or down allows you to have a more complete circular edge around the image because only one section of the edge, instead of two, is cut off. You can use this as a compositional technique for directing the viewer's eye in the picture space.

Take a look at the following four photos to see how slight shifts of the lens change the visual balance of the photograph.

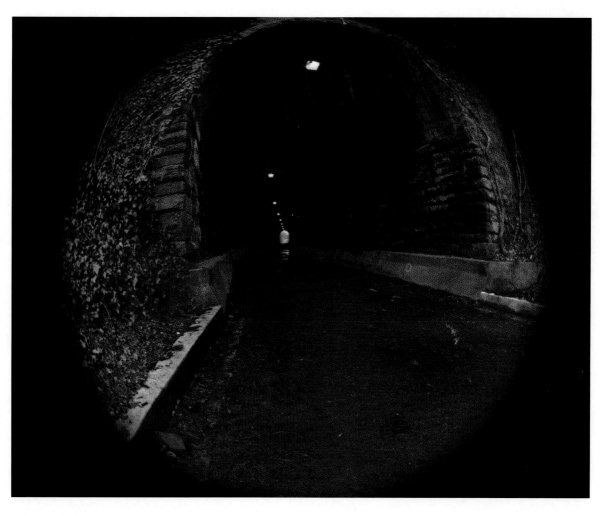

Fisheye Optic, f/8

Lens pointed straight ahead, fisheye circle is centered. Attention is focused on the path to the other end of the tunnel.

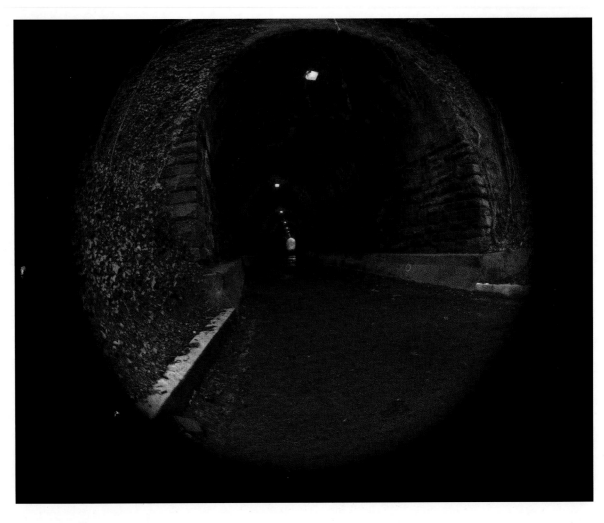

Fisheye Optic, f/8
Lens tilted up. With the top cut off and the bottom untouched, more attention goes to the foreground.

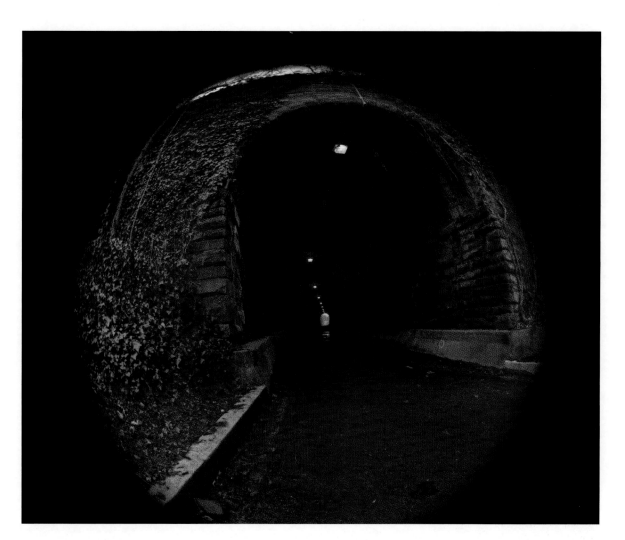

Fisheye Optic, f/8

Lens tilted down. Showing a little sky above the arch draws the viewer's eye to the upper part of the photo, then into the tunnel. It's my favorite of the series.

Fisheye Optic, f/8

If you're using a full-frame camera and are having problems with what's cut off on the sides, switch to a vertical format. The image is circular, so it's the same composition whether vertical or horizontal, but now the top and bottom aren't close to the edges.

Flare Effect

The Fisheye Optic also offers a unique flare effect. The black area around the image will take on the color of a bright subject or light source near the lens. It will also pick up color from a light source such as the sun shining right into the lens. This is a pretty cool effect because it adds a ring of color to the image. And since it's often a color that's already in your photo, the color matches well to the image. This effect is most intense along the circular edge of the photo. On full-frame cameras it is more apparent because there's a larger black area to pick up color. In the viewfinder you can see the color that's being picked up. Changing your angle to the subject can shift the way the color appears around the image. For example, instead of being an even band of color all the way around, the intensity of the color could vary. Again, you'll be able to see this through the viewfinder. In some cases of very intense light, the entire black area on a full-frame camera can be colored.

Lensbaby Composer, 12 mm Fisheye Optic, f/4

The candle inside the pumpkin threw out enough light to create the orange flare. The flare wouldn't wrap around entirely, so I found an angle where it would illuminate the right side to help draw the viewer's eye across the image. Round subjects work great because they match the shape of the Fisheye image.

Sometimes there is color around the image, but it's not bright enough to be noticeable. In these situations, a proper exposure for the subject resulted in underexposing, if you will, the band of color. Perhaps you'd like to see the color better, but if you made the photo brighter, your subject would be overexposed. The solution? Take two exposures. The first is a good exposure for the subject and the second is a lighter exposure to record the flare color.

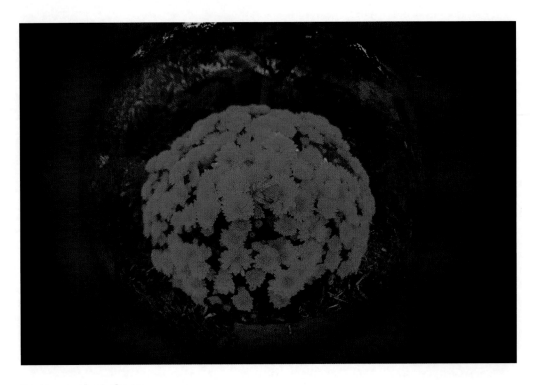

Good exposure for the flowers

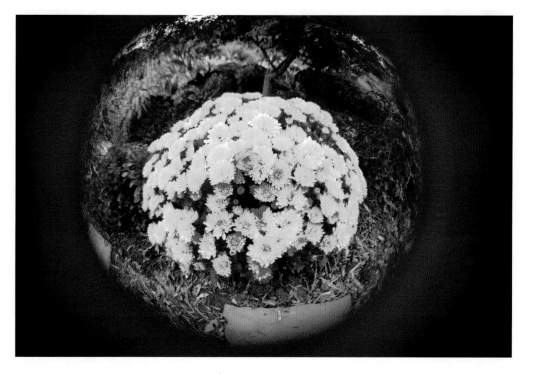

A brighter exposure brings out the color of the flare

The shutter speed for the first exposure was 1/250th. You can see there's some yellow around the edge, but it's not vibrant. The exposure for the second picture was 1/60th. Now the yellow comes to life, but the flowers are grossly overexposed. To get the best of both photos, I brought them into Photoshop and used a layer mask to combine the bright yellow flare with the well-exposed flowers.

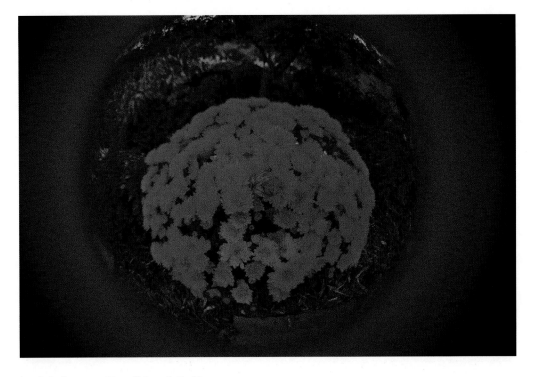

Lensbaby Composer, 12 mm Fisheye Optic, f/4

Final image: Best of both exposures.

Here's the step-by-step:

1. Open both photos, then make the overexposed image the active window.

2. Go to Select > All, then Edit > Copy.

3. Switch to the second exposure and choose **Edit > Paste**. Now you have each photo as a separate layer in the Layers Panel.

4. Select the top layer and add a layer mask (**Layer > Layer Mask > Reveal All**).

5. Choose the Brush Tool, then set black as your foreground color (press **D**, then **X**).

6. Paint, with a soft brush, the area inside the flare circle. The properly exposed image on the layer below will be revealed.

The Layers Panel after painting the layer mask

Completed layer mask for creating a black border around your fisheye image.

Creating a Black Border

A solid black border surrounding a full-frame fisheye image can be striking. If you don't want a ring of color around your photo or if it's dark around your photo but not dark enough, try this quick adjustment in Photoshop or Photoshop Elements®.

1. Add a Levels Adjustment layer (Layer > New Adjustment Layer > Levels).

2. In the Levels adjustment, hold down the **Option** (PC: **Alt**) key while you drag the black slider to the right. Drag the slider until your image shows a solid black ring around the center. It's okay if areas in the center also turn black or other colors. Click **OK** (if necessary) and go to the Layers Panel.

3. Choose the Brush Tool, then set black as your foreground color (press **D**, then **X**).

4. Click on the layer mask for the Levels Adjustment Layer. Paint, with a soft brush, the area of your photo inside the black border. This will remove any darkening that affected your photo while leaving the black border untouched. See the screen shot of the Layers Panel on this page, which shows the completed layer mask.

COMMERCIAL
portfolios

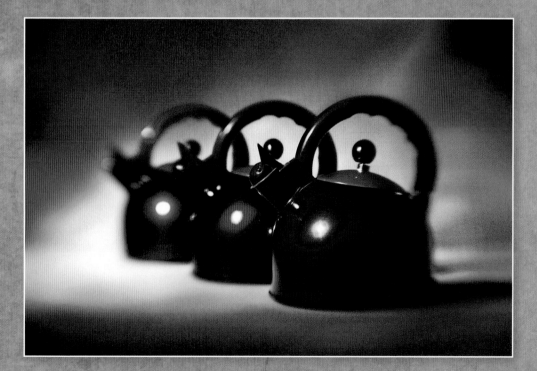

Jim DiVitale

Clients don't come to Jim DiVitale specifically for Lensbaby shots. But that's no reason to assume that a Lensbaby photo won't appeal to them. Commercial photography assignments often have a specific focus in terms of how a product or concept should be portrayed. Individual compositions may be laid out in detail by the client. Jim will first shoot what the client wants, then take additional photos using a Lensbaby, to offer an alternate look. And sometimes it's these additional shots that grab the client's attention. One client liked the Lensbaby versions so much they only used Lensbaby photos for the project. Since clients likely aren't aware of a Lensbaby or the Lensbaby look, show them what's possible.

Jim's commercial assignment photography often requires taking multiple photographs of the same product/set-up, then later combining them using Photoshop. Each photo serves a different purpose as part of the final image. However, the lens needs to stay in the same position to ensure that the composition is unchanged and that all photographs are taken from exactly the same perspective. This attention to detail is critical so that when the images are brought into Photoshop everything registers. The Lensbaby 3G was the first Lensbaby that Jim could use for these applications because he was able to position the lens, lock it in place, then fine-tune the focus to target the exact point he wanted sharp. Jim currently uses the Composer. It gives him the flexibility to use it when handholding the camera in the field as well as for studio set-ups. When working in the studio he's usually shooting from a tripod, with his camera tethered to a computer so he can review the photos as he's working. Jim most often chooses one of the middle apertures for a moderate depth of field. He also uses the Wide Angle and Telephoto Lenses plus the Macro Kit.

While there are software techniques and other equipment that can produce a selective focus effect, Jim thinks the Lensbaby look that stretches or "mushes" the out-of-focus areas is unique. He prefers to create this effect in camera whenever possible. Compared to other camera systems/lenses that offer ways to create a selective focus look, the Lensbaby is the one that's the most adjustable on the spot (when you're taking the photo). Of course, Jim does not shy away from using technology to produce better photographs, as illustrated with his combining of multiple images, but by having the Lensbaby take care of creating "the look" for the individual photos, he can concentrate on bringing them together on the computer and not having to create "the look" in the first place.

Whether it's for personal or commercial work, Jim enjoys experimenting with the Lensbaby. He finds this leads to "happy accidents" when you get something you didn't expect, sending your photograph down a different road than you planned. Jim's advice is that it's easy to take a photo with a Lensbaby, but it requires practice to capture really good, creative photos. After using a Lensbaby you start to see things differently.

To see more of Jim DiVitale's photography, visit divitalephotography.com

© **Jim DiVitale**
Lensbaby 3G (double glass)

No fancy image processing techniques were required for this photo. Using a digital projector, Jim projected the Photoshop panels on his computer screen onto a ceramic hand. In the background is a handmade paper with a tungsten light behind it.

© **Jim DiVitale**
Lensbaby 3G (double glass)

This photo appears to be a complex combination of lights using colored gels. In reality these teapots were lit with a single white light (shone through a piece of shower glass). Multiple photos were taken with the light in different positions to capture varying light patterns and reflections. The rainbow of colors is created by combining the color channels (Red, Green, Blue) from different images—for example, using the Red Channel from image 1, the Blue Channel from image 2, and the Green Channel from image 3. Jim calls it the Kaleidachrome effect.

© **Jim DiVitale**
Lensbaby 3G (double glass)

The motorcycle was photographed in a studio for use in an advertisement. After shooting the planned set-up for the client (a straight shot), Jim moved in closer, handholding the Lensbaby, to focus on the details of the motorcycle.

© **Jim DiVitale**
Lensbaby 2.0 (double glass), Macro Kit

Old printing plates offered a unique photo opportunity. Using the Macro Filters and shooting handheld, Jim concentrated on the details of the plates. A selection of the images was then used to create this composite. The plates were illuminated by a single tungsten light.

© **Jim DiVitale**
Lensbaby 2.0 (double glass)

The Lensbaby's sweet spot made it possible to create a fanciful image of the toy plane circling the globe. Bark paper was used for the background, and the lighting was a single tungsten light slightly diffused by shining it through a piece of textured glass.

four

ACCESSORIES

Accessories

Most accessories can be used with any of the Lensbaby lenses (past and present) and optics. There are just a couple restrictions. The Original Lensbaby cannot use the Creative Aperture Kit. The aperture discs are a little too wide, but you could make your own discs if you want. The Fisheye Optic has very limited compatibility with the accessories. The only accessory it can use (with limitations) is the Creative Aperture Kit (details in that section). The rest of the accessories cannot be used with the Fisheye, because they're unable to attach due to the lack of front threads. Even if something could be attached it would show up in the photo because of the Fisheye's wide angle of view. Here's the accessory list:

> Macro Kit
>
> Wide Angle/Telephoto Kit
>
> Super Wide Angle Lens
>
> Creative Aperture Kit
>
> Step-Up/Shade
>
> Custom Lens Cases

Macro Kit

If you are looking to get close and photograph the small wonders of the world, grab the Macro Kit. The kit comes with two close-up filters that screw into the front of any of the Lensbaby lenses. The filters come in a little pouch that takes up almost no space, making them easy to carry with you. The filters come in two strengths: +4 and +10. The stronger the filter, the closer the photo you can take. The +4 will allow you to focus 6 to 13 inches from your subject. The +10 lets you get within 3 to 5 inches of your subject. Not close enough for you? Stack the filters and you can be 2 to 3 inches from your subject! The order in which you stack the filters doesn't affect the close-focusing ability. When you get really close to a subject, you can find amazing abstract photos that you'd never see with just your eyes.

Even if you're a fan of using a wide aperture (like me), macro photography is a time to consider trying out the smaller apertures of f/11, f/16, or f/22. Just as with a regular lens, the more you magnify something, the less depth of field you have at a given aperture. Take the limited depth of field you already have with a Lensbaby at f/4 and put on a macro filter, and you have even less depth of field. Don't get me

Lensbaby 3G (double glass), f/4, +10 Macro Filter

Careful bending and focusing was required to place the sweet spot on the smaller flower. The 3G's fine-focus ring was indispensible.

Lensbaby 3G (double glass), f/4, +4 and +10 Macro Filters, stacked
I stacked the Macro Filters to get as close as possible to the center of the flower, letting the petals become the backround.

wrong; you can definitely go for abstract or really soft images. However, if you're looking to have a larger area of sharpness (or better definition in the background), using a smaller aperture disc will get you there. It's all about the look you're going for.

Depth-of-Field Comparison

Take a look at how the detail in the subject and the background change when a smaller aperture is used.

f/2 (Double Glass Optic)

With no aperture ring, the seed pods are barely defined. The lack of depth of field creates a glow around them.

f/4 (Double Glass Optic)

The glow has disappeared and the cluster of seed pods is beginning to take shape.

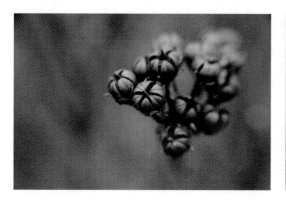

f/8 (Double Glass Optic)

Better definition of the cluster. The background has subtle lines and variations in tone.

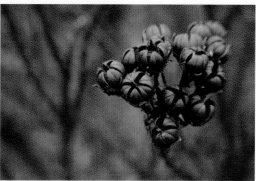

f/16 (Double Glass Optic)

The entire cluster is well defined and there are distinct lines in the background.

A Piece of the Whole

Also think about photographing a portion of an object for an intriguing macro shot. Compare these two photos of a candle.

Lensbaby Composer, Plastic Optic, +4 Macro Filter

Photographing the entire candle shows what it is, but it doesn't make for a particularly interesting composition.

Lensbaby Composer, Plastic Optic, +10 Macro Filter

By moving in closer to include just a portion of the candle-holder, I was able to find a more compelling composition. Getting down lower also made it possible to line up the flame with the hole in the fish-shaped decoration.

Tips for Close-up Photos

- Get close: Fill the viewfinder with your subject.

- Once you think you're close enough, get closer!

- Look for colorful backgrounds.

- Carefully choose where to focus, since very little will be sharp.

Wide Angle/ Telephoto Kit

For those times when you can't (or don't want to) move closer or further away, the Wide Angle and Telephoto accessories come in handy. These lenses screw into the front of any model of Lensbaby. The Wide Angle Lens will shift your Lensbaby from being a 50 mm lens to a 30 mm lens. Use the Telephoto Lens to reach out to an 80 mm focal length. Use these adapters to get a tighter shot or a wider view; it's the same idea as deciding to zoom in or out with a regular lens. You can also use these lenses for close-ups by pairing them with one (or both) of the filters from the Macro Kit. Attach the macro filter first, then the Wide Angle or Telephoto Lens.

If you bend the Lensbaby too far when you're using the Wide Angle Lens, the lens will come into the picture and your photo will have a black edge. If your camera has an APS size sensor, you have a fairly unrestricted range of motion. You have to bend the lens pretty far to get a black edge in your photo. Using a full-frame camera, you're a little more restricted; you can bend the lens but not in significant amounts.

Sensor Size

Keep in mind that if you're using a camera with an APS size sensor, the focal length of the Lensbaby by itself is about 75 mm instead of 50 mm. This means that using the Wide Angle takes you to 45 mm and the Telephoto becomes 120 mm.

Filter Tip

The filter size for the Wide Angle and Telephoto Lenses is 46 mm.

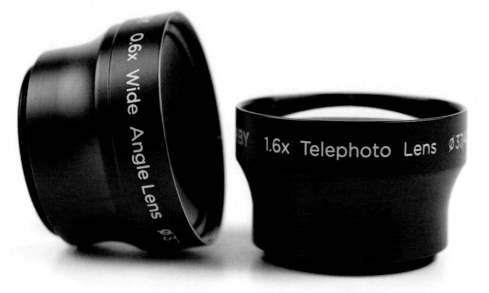

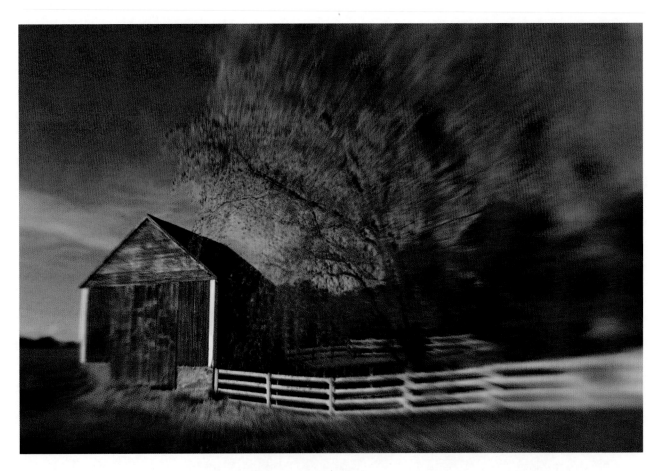

Lensbaby Composer, Double Glass Optic, f/4, Wide Angle Lens

The Wide Angle Lens made it possible to capture more of the scene without having to change position (which would have shifted the perspective).

Lensbaby Composer, Double Glass Optic, f/4, Wide Angle Lens

An extreme bend to the right brought the edge of the Wide Angle Lens into the photo, which acts to frame the left side. The distortion that's "bending" the left side of the building away acts as a compositional aid, drawing more attention to the decoration on the right.

The Wide Angle Lens also produces barrel distortion, which bends horizontal and vertical lines near the edges and can give the center a bulging look. The distortion is more apparent with full-frame cameras. It can still be obvious with APS size sensors the closer you are to your subject and the more you bend the lens.

Lensbaby Composer, Double Glass Optic, f/4, Wide Angle Lens

No extreme bending here; simply moving in close to the door with the Wide Angle Lens was enough to create the distortion.

Super Wide Angle Lens

If the Wide Angle Lens isn't wide enough for you, take a look at the Super Wide Angle Lens. It works with all Lensbaby lenses, though with the Original Lensbaby you'll need to use an adapter, which is available from Lensbaby. On a full-frame camera, the Super Wide offers an impressive field of view, changing the Lensbaby focal length from 50 mm to 21 mm. If your camera has an APS size sensor, the resulting focal length will be about 31 mm. Although this might not be "super wide," it puts you well into the wide-angle range (remember, with the regular Wide Angle Lens you're only slightly wider than 50 mm). The size of your camera's sensor is an important factor to consider when you're looking for a wide-angle option. The Super Wide used with an APS size sensor gives you a comparable view (31 mm) to a full-frame camera with the regular Wide Angle Lens (30 mm). If you're using an APS size sensor and want to truly be in the wide-angle range, go with the Super Wide.

In addition to going for an ultra-wide scene or landscape, try moving in for close-ups, too. The Super Wide can focus quite close, down to just under 3 inches. Get in really close to a small

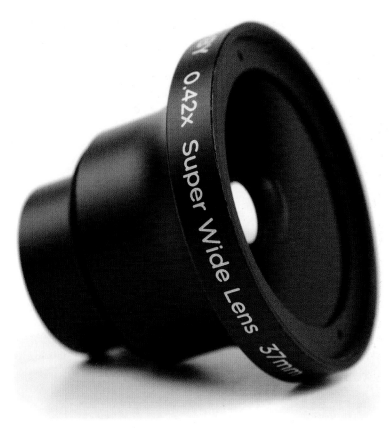

Sweet Spot

The sweet spot stays small, even with the wider view, which produces particularly heavy blurring around the edges.

Lensbaby Composer, Double Glass Optic, f/4, Super Wide Angle Lens

To have a strong foreground element, I moved in very close to the red stake in the ground (which says "Asparagus"), then chose a perspective that lined up the stake diagonally with the shed in the background.

subject to make it prominent in the composition. Even at close range you'll capture a lot of background, creating a close-up photo that's quite different from those taken using the Macro Kit.

As with the regular Wide Angle Lens, if you bend the Lensbaby too far with the Super Wide you'll see the lens in the edge of your photo. With an APS size sensor you can bend the lens a moderate amount; only extreme bending will be a problem. If you're using a full-frame camera,

you'll want to keep the lens pointed straight ahead to avoid vignetting (darkening in the corners of your image). How far away you focus will also affect whether vignetting occurs. When you're focusing on a subject that's very close, you won't get the vignetting with the lens straight ahead and you can even bend the lens a little and still be okay. However, if you are focused on a subject further away, there can be vignetting, even if the lens is perfectly straight.

Chromatic Aberration

When using the Super Wide, you are more likely to see chromatic aberration (color fringing) in your images, even if you're using a multi-coated optic such as the Double Glass.

Lensbaby Composer, Double Glass Optic, f/4, Super Wide Angle Lens

The ultra-wide view makes the construction fences look like a tunnel. Note the vignetting, even with the lens pointed straight ahead (full-frame camera).

Wide Angle-Telephoto-Super Wide Comparison

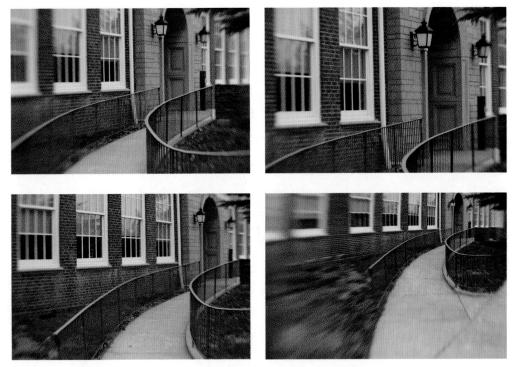

Top Left: No Attachments
(Double Glass Optic)

Top Right: Telephoto Lens
(Double Glass Optic)

Bottom Left: Wide Angle
Lens (Double Glass Optic)

Bottom Right: Super Wide
Angle Lens (Double Glass
Optic)

Creative Aperture Kit

The Creative Aperture Kit gives you the opportunity to have some fun with bright light sources and specular highlights. The circular opening in a regular aperture disc causes out of focus points of light to be round (or oval shaped depending on the bending of the lens). The Creative Aperture Kit lets you change the shape from circular to … well, whatever you want! The standard kit comes with seven aperture discs. Two of them already have an opening cut in them (a heart and a star); the rest of the discs are solid (no opening). With these blank discs, you can cut your own aperture shapes and designs. The heart-and-star aperture are equivalent to a round f/4 aperture. There's also a Blank Kit available that includes 10 blank discs. To make your own shapes, you can use

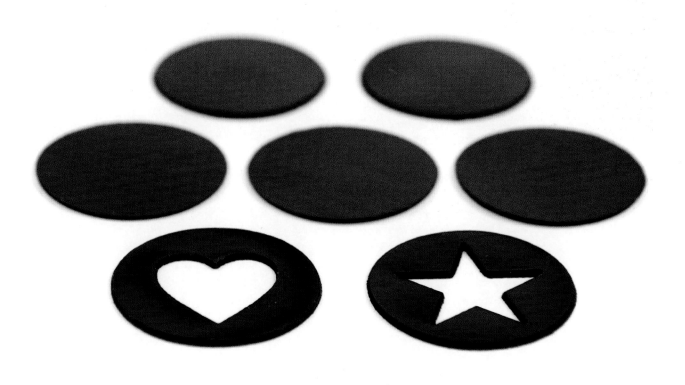

Fisheye + Creative Apertures

To use creative apertures with the Fisheye Optic, you'll need to cut your own shapes. The heart and star shapes will not work because the openings are too large. If you drop one into the Fisheye, the edge of the shape is outside the glass, meaning it'll have no effect on the image. When cutting your own shapes, make sure the entire shape fits within the glass of the Fisheye.

paper punches, which come in many shapes and designs. Search online for paper punch shapes or check out a local craft store. You can also use an art blade to cut shapes yourself. However you are cutting them, make sure to cut or punch with the shiny side of the aperture disc facing up.

Aperture Shape Comparison

Here's what an out-of-focus light source looks like with round, star, and heart shaped aperture discs.

Subjects for Creative Aperture Effects

Photographing in a city a night is a particularly sure-fire way to see the effects of your creative apertures. With bright lights in buildings, along streets, and across bridges, you'll see the shapes take form in the viewfinder, right before your eyes. The more out of focus the bright point of light, the larger and more clearly defined the shape will be. This can be something that's difficult to visualize with just your eyes, so use your viewfinder to guide you to the right composition. Specular highlights, such as when a light source glints off something shiny, will also take on these aperture shapes. Another situation to look for is light coming through leafy trees. The light shining through

the leaves will often turn into a pattern/texture of the aperture shape you're using.

I was doing a bridal shoot in Balboa Park. At dusk all the lights come on, so I pulled out the star aperture for my very theatrical bride. We got lots of pretty twinkling stars with soft light before dark, so after dark we went to the fountain for some silhouettes. I knew the string of lights behind the fountain and the star aperture would look nice together. We created a very stylized pose for this tall, graceful bride, and all elements combined made for a very dramatic image.

Anything with a reflective surface has the potential to be good material for creative aperture shapes. Take this close-up of sleigh bells, for instance. Lights were reflecting in the bells, and when I focused on the bells, the points of light turned into stars. With highly reflective objects, even small adjustments to the camera's position can significantly change the reflections. I tried many compositions from various angles to find the best arrangement of bells and stars.

After taking the in focus photo of the bells, I thought back to the out-of-focus shot. To create an image with even more stars, I blended the two photos using my camera's Image Overlay feature (for more on overlays, including how to create them, see Chapter 5).

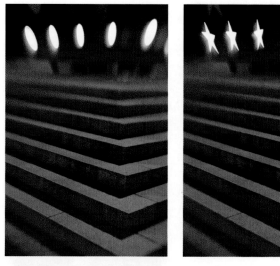

Top Left: Regular (round) f/4 aperture disc (Double Glass Optic)

Top Right: Star aperture disc (Double Glass Optic)

Bottom Left: Heart aperture disc (Double Glass Optic)

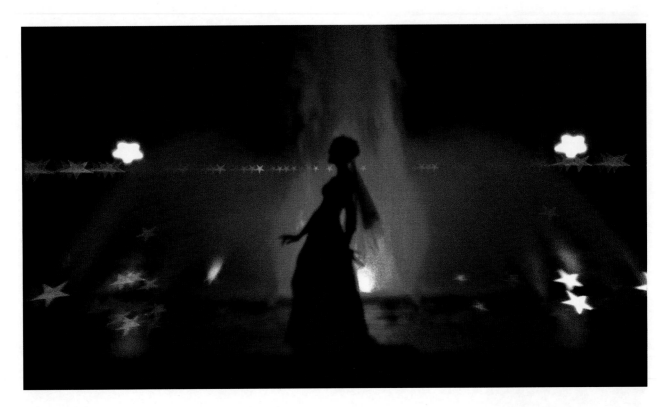

© **LisaSmithStudios.com**
Lensbaby 2.0 (double glass), star shape aperture

Lensbaby Composer, Double Glass Optic, star shape aperture, +10 Macro Filter

Lights reflected in the bells turn into stars with the star aperture disc. When I began exploring the reflections in the bells, I snapped this completely out-of-focus picture that was all stars (there were multiple rows of bells).

Out of focus reflections off bells

Overlay of the sharp bells and out of focus stars

© **Kirsten Hunter**
livefrombeechstreet.blogspot.com

Lensbaby 3G (double glass), homemade aperture

I had a handful of homemade apertures that I was dying to try out, and I went to a birthday party where the DJ had this fiber optic thing on his stand. I tried most of the apertures out on it, but this shot was my favorite. Since the subject is so abstract I purposefully tried to get as much of the creative aperture effect as I could. This shot was not about sharpness; it was more about the creative aperture.

Step-Up/Shade

The Step-Up/Shade is a combination step-up ring and lens shade that screws into the optic threads. As a lens shade it helps avoid flare by blocking light from shining directly into the lens. As discussed in the Optics section, some optics are more prone to flare. If you're looking to use flare as a creative effect, you might not want to use this attachment.

As a step-up ring, the Step-Up/Shade allows you to use 52 mm filters with your Lensbaby. The Lensbaby's own filter threads are 37 mm, a filter size that's not as readily available as 52 mm. Using this ring, it's much easier to use filters such as a polarizer, neutral density, or special effects filters (see Chapter 5 for more ideas on using filters).

Regular step-up rings and lens shades will not work with the Composer or Control Freak/3G because the shape of the rings interferes with the focusing mechanism. When you focus further away, the focusing mechanism pulls the optic back into the lens. If you tried to focus using a regular step-up ring or shade, it would run into the outer edge of the lens, limiting the lens' focusing ability.

**Step-Up/Shade
Compatibility**

The Step-Up/Shade cannot be used with the Wide Angle, Telephoto, or Super Wide Lenses because their front filter threads are too large.

Custom Lens Cases

To keep your Lensbaby safe when it's off your camera, Custom Lens Cases are available in two versions: one for the Composer/Muse and one for the Control Freak/3G. They offer good protection for your lenses, and since they're only a little larger than the lenses, they don't add much bulk.

Composer/Muse Custom Lens Case

Control Freak/3G Custom Lens Case

LANDSCAPES

portfolios

FLOWERS

AJ Schroetlin

Tony Sweet

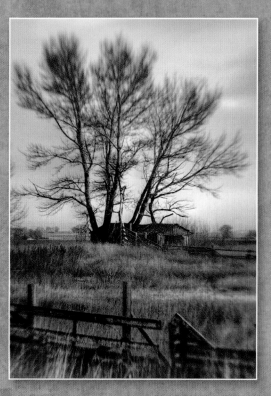

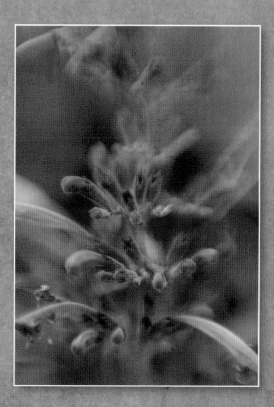

Landscapes

AJ Schroetlin

Growing up in the beautiful state of Colorado left me very little choice but to be aware of my surroundings, from the massive 14,000-foot peaks in the west to the miles and miles of open prairie in the east. Couple this with parents and grandparents who love both nature and art and I was destined to become a landscape photographer. Their support keeps me motivated as well.

In 2005, at the age of 32, I bought my first "real" camera. Shortly after, I bought a Lensbaby 2.0. I put the lens on my camera and it stayed there. For months. I would go out to my favorite nature areas and shoot hundreds and hundreds of images as I learned about photography. The Lensbaby is so fun to use because it immerses you into the scene. It's like a story, and you get to control the mood by bending the lens. The control and thought process involved in using a Lensbaby are among the things I like about them. Since I was still learning the basics of photography at the time, it also became a fantastic teaching tool. Having to change out the aperture discs helps you learn what aperture means. Using your camera in a manual mode forces you to learn how shutter speed and aperture work together to create a "correct" exposure.

What I learned in those first couple years is that most of the basic rules of photography apply with a Lensbaby as with any other lens. Nice light is always important, especially when shooting landscapes. You are better off waiting for the right day and the right time to photograph a place instead of capturing a mediocre image because of flat, boring light. It is about "the right place at the right time," but often you can figure out where to be by paying attention to your surroundings. Watch the seasons and the sun to find the right place as well as when to be there.

To find out more about AJ Schroetlin's photography, contact him at ajthedaydreamer@juno.com

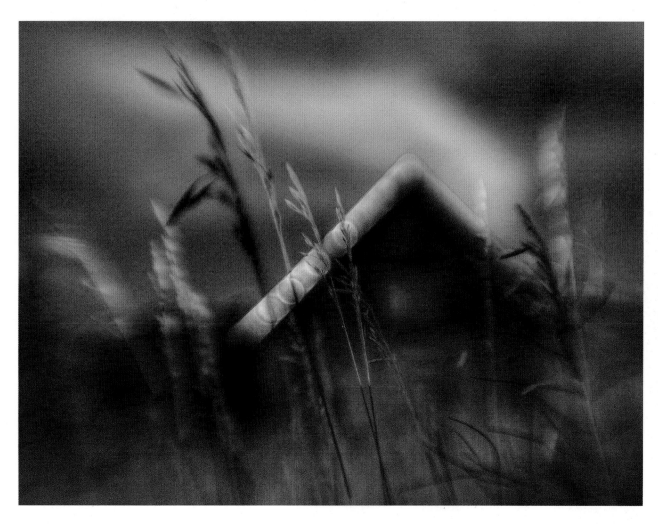

© **AJ Schroetlin**
Lensbaby 3G (double glass), f/2.8, Polarizer

For this image I wanted to try something different, so I focused on the overgrown weeds surrounding an old homestead. The colors in the scene are what drew me in.

© **AJ Schroetlin**
Lensbaby 2.0 (double glass), f/4

This type of image is what makes the Lensbaby unique: the ability to tilt the lens to make it follow the path of the ground, creating front-to-back focus.

© **AJ Schroetlin**
Lensbaby 2.0 (double glass), f/5.6

I liked this perspective to help give the appearance of wind in the foreground. It also gave me a clear focal point, which is important in using a Lensbaby.

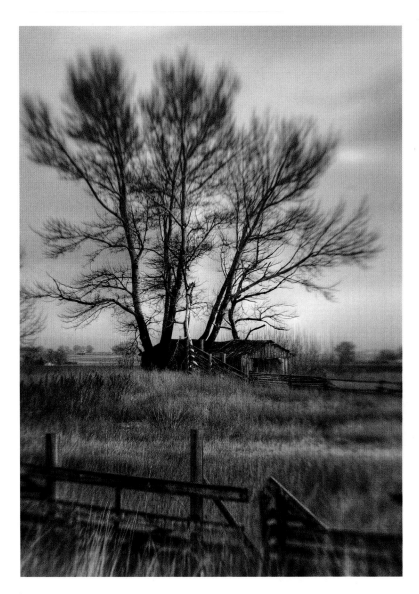

© AJ Schroetlin
Lensbaby 2.0 (double glass), f/2.8

I think the Lensbaby is great for photographing old structures like this barn because it helps show the effects of time.

© **AJ Schroetlin**
Lensbaby 2.0 (double glass), f/2.8

One of my favorite things in life is walking next to a river. The sights, the sounds, and the feelings of peace are unmistakable. Sometimes looking in different places leads to the best image.

Flowers

Tony Sweet

Lensbaby has been an integral part of my gear since its inception. The look is unique, and with the new optics, the creative photo horizons are unlimited. To me, Lensbaby is a great and expressive lens for flower photography. From the wide open look to the soft optic to the fisheye optic to the ultra wide lens, Lensbaby is an increasingly potent and original tool for creative interpretation.

My photographic approach, when using Lensbaby, is to photograph flowers wide open, with no aperture disc or with a large aperture disc, not to exceed f/5.6. This results in very selective focus and an overall soft/pastel image. The smaller the aperture, the more the image sharpens, canceling out the Lensbaby characteristic edge blur. However, I'll use f/16 and f/22 aperture discs when using the close-up filters, especially when I have the +4 and +10 close-up filters stacked together, to gain minimal selective sharpness.

Handholding and tripod mounting the Lensbaby both have advantages, depending on the subject and what I'm after. Handholding the Lensbaby gives more room for freedom and spontaneity, although I may miss on sharpness, and I'll shoot several exposures of the same image, checking the magnified image in the viewing screen, to ensure that I have the sharpness that I want for the specific subject.

I'll opt to use a tripod when possible and practical, to study my composition and to very carefully focus into the subject. A cool tip is to use Live View, if your camera offers it, to greatly magnify the area where you want to have the greatest sharpness. However, since there is no autofocus capability, I'll still need to shoot several exposures to get what I want.

Here are a few more cool tips:

1. The Super Wide Lens and the Fisheye Optic can focus very close to the subject—the Super Wide within a few inches and the Fisheye when touching the subject, resulting in some very cool interpretations.

2. With the Control Freak, it's possible to push the lens outward, to be able to focus even closer to the subject while dramatically softening the background.

3. Always strive to get soft, colorful backgrounds.

Equipment

Lenses: Composer, Control Freak, and Lensbaby 2.0

Optics: I have them all, but my most used are Double Glass, Fisheye, and Soft Focus

Accessories: Macro Kit

To see more of Tony Sweet's photography, visit tonysweet.com

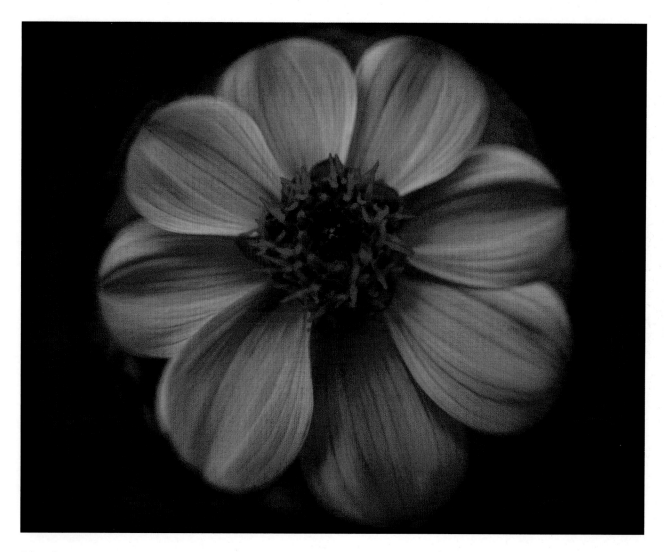

© **Tony Sweet**
Lensbaby Composer, 12 mm Fisheye Optic, f/2 (no aperture disc)

The Fisheye was handheld 1 inch from the subject, using Live View to compose. I used my fingers to focus while viewing sharpness in the LCD.

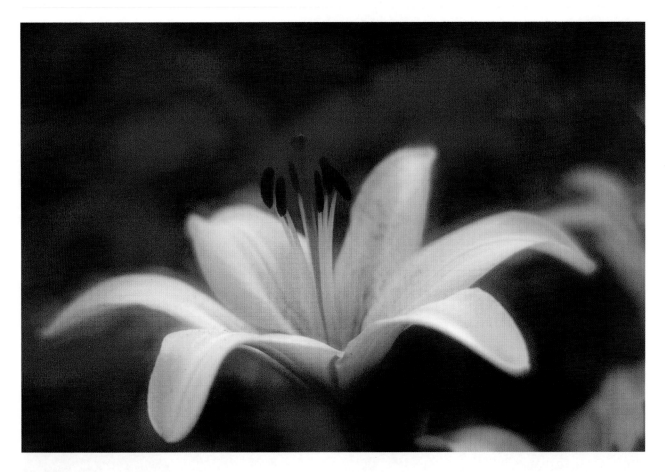

© **Tony Sweet**
Lensbaby Composer, Soft Focus Optic, f/4 soft focus aperture disc

Looking for a colorful background far enough behind the subject so that I could use the f/5.6 aperture to achieve sharpness in the subject while maintaining a soft, unobtrusive background.

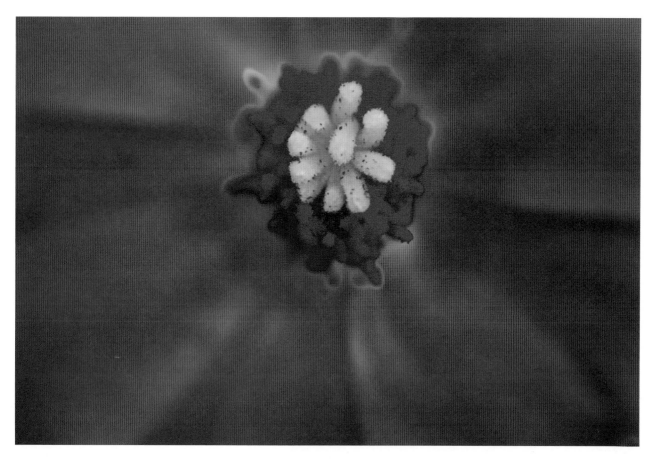

© **Tony Sweet**
Lensbaby 3G (double glass), f/22, +10 Macro Filter

In high magnification macro, a smaller aperture disc is required if you want to achieve any sharpness whatsoever. In this case, the tripod mounted camera was focused very close to the small flower, and the fine tuning focusing on the 3G was great for the critical focusing.

© **Tony Sweet**
Lensbaby 3G (double glass), f/2 (no aperture disc)

This image was handheld to get into a tight situation.
Although I like the magnification in the viewer, the Lensbaby
was within the minimum focusing distance, thus unable to
focus. The 3G can be pushed outward to focus closer, creat-
ing a shallower depth of field and much softer background.

© **Tony Sweet**
Lensbaby Composer, Soft Focus Optic, f/4 soft focus aperture disc

Normally, I would avoid this type of image because of the busy background with the sticks and patchy purple flowers. The soft focus nicely separated the subject from the busy background. The marble-looking background is a function of the Soft Focus Optic.

LENSBABY VISION

You now know a bit about all the optics and accessories you can use with the Lensbaby. My, there are a lot of them! It can be energizing as well as overwhelming to think about all the options and possibilities. When you're figuring out what you want to use with your Lensbaby, consider the subjects you like to photograph and your personal photographic style. Think about the types of photos that appeal to you. What do you see that makes you think, "I want to take a photo like that"? Perhaps you really like the Fisheye's distortion and wide angle of view. Are you drawn to the tiny elements you can bring to life with the Macro Kit? Or is it the super-dreamy look of the Plastic Optic? If you're not sure what look a particular optic or accessory will produce, search online for examples of what others have shot with that optic. The Lensbaby website is a good place to start. There you can find galleries of photos taken with the various optics and accessories.

The array of options is wonderful as they offer so many creative ways to use the Lensbaby. The styles of photographs you can capture are diverse, from the Pinhole/Zone Plate Optic to the Super Wide to the Macro Kit. Do you need them all? Let me be the first to say you don't *need* everything. And even if you have lots of Lensbaby gear, it doesn't mean you have to bring it all with you. I can say from experience there is such a thing as bringing along too much! To decide what would be the most useful to have with you, think about what you plan to photograph. What gear matches up best with the subjects you'll be photographing?

Self-Assignments

If you're looking to push your creativity and find new ways to use your Lensbaby equipment, try a self-assignment. Choose an optic or accessory you don't use much. Then go out for an afternoon and use it for all the photos you take, regardless of the subject. Do you have the Soft Focus Optic but don't use it much? Have you tried stacking the macro filters together? Ever used a small-aperture disc or no disc at all? Use self-assignments to move yourself away from what you're comfortable with. They offer a way to focus on using a particular piece of equipment or on a specific subject. They're an opportunity to photograph in a way that's outside what you normally do. It can do wonders for your creativity. By making yourself focus on one optic or accessory, you give yourself the chance to get to know it better. You can learn what

subjects/situations it works well for and what it doesn't. You may find it's your new favorite accessory or that you truly can't stand it! Knowing your equipment enables you to choose the right option for the subject or the effect you want to create.

Another way to use self-assignments is to choose a particular subject, photographic style, or theme. Focus on a subject: buildings, people, flowers, landscapes. Too broad? Be more specific: windows, butterflies, signs, hands, faces, toys, cars. Or you could pick a feature such as color, shape, texture, or line. Photograph only things that are red. Include triangles in all your photos. Make diagonal lines dominant in your compositions. The options for self-assignments are unlimited. The idea is not to do what you've been doing. Take the time to learn from your assignments and they'll help you expand your skills and how you see things photographically.

Aperture Considerations

Choosing the right aperture for the type of image you want is an important consideration. Think about the effect the aperture will have on depth of field. How will a more or less distinct image affect the presentation of the subject? As I've mentioned before, most of the time I use the f/4 disc. For many subjects it offers me the right balance between blur and sharp. I use it as my starting point. Depending on the subject and/or the photo I envision, I'll go to a wider disc, a smaller disc, or none at all. Generally, if I'm going to switch aperture discs, it's to go to a wider disc. If I want a softer, dreamier look (with any of the sweet-spot optics), a wider aperture is the way to go. I'll also go wider to further soften the background or foreground.

Compare the two photos of chickens. Both were taken with the Single Glass Optic; the only difference is the aperture. The sharper one was shot at f/4; the softer one was shot with no aperture disc (f/2). A couple stops in aperture made a huge difference. I switched to the wider aperture to solve a problem: There was too much detail around the chicken. Sure, it wasn't all tack-sharp, but much of it was distinct enough to be a distraction. All the viewer's attention is not on the subject. It wanders around to what's on the ground and what's in the background. However, pull out that aperture disk and it's a whole new

photo. The chicken now stands out from its surroundings. The fence is still apparent, but that doesn't bother me as much my eye wandering to the dirt in the f/4 photo. With a slight change in perspective, the fence has become a pattern filling the entire frame. The composition has been simplified to chicken and fence. Taking these photos was a bit like action photography because the chickens didn't hold still for long. I had to constantly adjust my position and composition, all the while focusing because I didn't know when composition and behavior would converge to make a strong image. I was aware of the fence and I attempted to use it as a frame for the chicken. Persistence pays off. Out of 15 or 20 photos of these chickens, there was one where everything came together.

f/4 (Lensbaby Composer, Single Glass Optic, Telephoto Lens)

f/2, no aperture disc (Lensbaby Composer, Single Glass Optic, Telephoto Lens)

The main reason that I don't regularly use smaller apertures is that I lose the Lensbaby look. Too much of the image comes into focus, and though it's not all tack-sharp, it's lost many of the qualities that make it a Lensbaby photo.

In some situations, such as macro photography, I'll consider a smaller aperture because of the reduced depth of field. The more you magnify an object, the smaller the depth of field. For some macro subjects, an extremely soft, almost hazy look works very well. Other times I want the subject to be more defined. In those cases I'll turn to a smaller aperture. For close-up photos, even using f/22 isn't likely to bring the background into sharp focus, especially if the background isn't close to the subject. Keep in mind that even though a background is out of focus, it can still be distracting if it's too distinct.

Streaking

To create a streaking effect in your photos, you'll first need to be using an optic that has a sweet spot (Double Glass, Single Glass, or Plastic). The streaking is caused by an extreme bend or tilt of the lens. By pushing the sweet spot far to one side, it causes the blurring of the opposite side to be stretched out, creating a streaking appearance. The effect can be even more pronounced if the area that's blurred is close to you and the sharp area is further away. The streaking look also gives a feeling of motion to the image.

Lensbaby 3G (double glass), f/4

I wanted the viewer's attention to be directly to the path on the right side of the scene. Shifting the sweet spot that far to the right caused the dogwood and azalea blossoms to be stretched out.

Let the Focus Go

Try forgetting about focusing altogether. It can be freeing to not have to think about getting something in focus, not having to decide where the sweet spot should go. When you're composing with nothing in focus, your photo is no longer about details. What becomes most important are color and shape. Certainly not everything, or even many things, will make a good photograph when they're completely out of focus. But it can be fun to check out the subjects you're photographing in a defocused state. You might be surprised at the possibilities.

Lensbaby 3G (double glass), f/4

To create the particularly heavy streaking in this photo, my camera was very close to the flowers in the foreground. I placed the sweet spot at the center of the top of the fence. The streaking has created some distinct lines in the lower half that point the eye up to the fence. I like the feeling of motion that's been created in this image. It's as though the viewer is moving at high speed over the flowers, toward the fence.

Lensbaby 3G (double glass), f/4

While photographing motorized toy sailboats on a lake, I relaxed my fingers on the lens, letting everything go soft. The red triangle is a boat's sail. Notice how the red still dominates the photo, even though it has no detail. The bright circles are from the sun glinting off the water. Defocusing has reduced the scene to its most basic form: circles and a triangle. Can't get much simpler than that.

Lensbaby 3G (double glass), f/4

There was a Christmas tree made out of lights decorating the side of a house. I was looking and looking for an interesting composition, but I wasn't coming up with anything I was happy with. Thinking about what to try next, I gave the fine-focus ring on my 3G a turn. Wow! As soon as I saw the out-of-focus tree take shape, I knew I had the shot. Amazing what the right form and shape can do. No detail, but instantly recognizable. Simple is good.

Lensbaby Composer, Plastic Optic, f/4, Telephoto Lens

Well, this one is a mostly out-of-focus photo. It's sort of a combination of shooting through and shooting out of focus. I'm inside a restaurant taking the picture through a rain-spattered window. I focused on the window to throw the boats in the marina out of focus, making the outside scene about color and shape. I tried focusing on the boats, but it wasn't nearly as interesting. Since I focused on the window, the raindrops are somewhat sharp, though I find their appearance to be like a texture overlaid on the marina scene. Using the Plastic Optic also helped soften up the raindrops.

Shooting Through

The wide apertures of the Lensbaby are just the right tools for the shoot-through technique. The set-up for a shoot-through photo is that there is something between you and the subject (something that you have to look through to see your subject). This thing between you and the subject is usually not solid. If it is solid, it can't be opaque. Fences, window panes, and window blinds can work well as shoot-through material. When you focus on the subject, whatever is in between will become significantly out of focus. You'll still be able to see it because the pattern, shape, or design of whatever you are shooting through will be overlaid on your subject. For best results, be close to whatever you are shooting through and have your subject at least a moderate distance behind it. If the subject is too close to the shoot-through material, you won't be able to get it out of focus enough. Being close to the in-between material makes it easier to throw that material out of focus. The best way to get a feel for the effect is to try it out. When you focus on your subject, you'll see this shooting-through effect happen in your viewfinder.

Lensbaby Composer, Double Glass Optic, f/4

For this image I was shooting through window blinds, which created the horizontal lines. By focusing on the city lights out the window, I made the blinds in the center go out of focus, allowing me to see "through" them. In addition to the shoot-through effect, the blinds help compositionally because they add a pattern over the clear sky. Imagine if the blinds were not there; two-thirds of the photo would be empty blue sky. It wouldn't be very attractive to have that much empty sky. The photo was taken at dusk, which made it possible to capture the city lights and still have color in the sky.

Lensbaby Composer, Plastic Optic, star shape aperture

I'm shooting through a window that's in a door and my subject is another door. I'm right in front of the door that's my shoot-through material. The door that's in focus is about 15 feet away. The faded diamond pattern is the design in the window I'm shooting through. One of the main composition considerations was how to line up the diamonds with the design in the far door. I can control this by changing my position. Changing my distance to the window changes the size of the diamonds. If I move closer, the diamonds become larger; move further away and they're smaller. Moving left or right would shift where the lines are but keep the diamond the same size. I opted to use one of the diamonds to frame a prominent element in the door: the circle with two figures in it. The use of the Plastic Optic gave everything a soft glow.

Reinventing the Ordinary

Don't forget about the little things, even if you're photographing big things. It can be the details that make a picture what it is. Look for creative ways to work with lighting or composition to turn ordinary subjects into eye-catching photographs. Here are a few oh-so-ordinary subjects and how they were made a bit more interesting.

Parking Garage at Night

The glow from the "windows" of the parking garage adds a bit of interest to what is basically a giant concrete box. But what stopped me in my tracks and made me get out my Lensbaby as quickly as possible was the light pattern spilling onto the solid wall. Combine that with the glow coming from where the two walls meet and I think it's fantastic. A photo of just the windows of the garage wouldn't have had nearly the impact. The shafts of light and the glow raise the level of the photograph.

Trashcan

Throw in a Creative Aperture disc and you've got something to work with. Actually, the Creative Aperture came first and the trashcan second. I'll explain. With the star aperture disc

Parking Garage at Night
Lensbaby Composer, Double Glass Optic, f/4

in my Composer, a set of lights in the distance turned into stars. The problem was I couldn't find anything to do with them, no interesting scene to use them in. But I was determined and I began looking for less conventional subject matter, which led me to the trashcan. The

Trashcan
Lensbaby Composer, Double Glass Optic, star shape aperture

challenge was how to bring the trashcan and stars together. I explored all sorts of angles and perspectives: more trashcan, less trashcan, up high, down low, vertical, horizontal . . . finally settling on a composition that focuses on the shapes around the top of the trashcan. When I look at this photo I see the stars falling into the trashcan, or maybe they're coming out of it. With the right conditions, something as ordinary as a trashcan can make for an interesting photo.

Clothes Pin

The only thing making this photo more than a clothespin on a line is the background. If you imagine a uniformly dark background instead, the photo loses most of its impact. The window panes behind the clothesline offered the opportunity to add another dimension to the subject. I carefully positioned my camera to "fit" the clothespin in the box created by the window panes. This placement highlights the clothespin as though it's on display. Also, notice that the box around the clothespin is the only complete box, further making that part of the photo unique. Framing is an effective technique when you want to call attention to a key element.

Clothes Pin
Lensbaby 3G (double glass), f/4

Timing

Timing is important in many situations, no matter what the subject; it can mean getting the shot or not. Let's take a look at situations in which the moment the shutter clicked made all the difference.

Ferris Wheel

The Ferris wheel wasn't moving while I was photographing it, so no worries about it spinning around, but that would have made for an interesting photo as well. The timing here had to do with the lights on the wheel. As I began taking pictures from different angles and reviewing them on my LCD screen, I noticed that the lights on the wheel's spokes cycled on and off. Unfortunately, I couldn't see a pattern to know when all or most of them would be lit. I knew I'd just have to take a bunch of photos and hope some of them had the right spokes lit. A smaller part of the wheel that was also changing was the star at the center. The star would get brighter and darker as well as go completely dark. With some test shots I determined that if the star was fully illuminated, it would be overexposed and have poor color. However, I could see a pattern and know when to shoot to capture it at a moderate brightness level. My timing wasn't perfect, but I knew what to look for, so I'd improved my chances to capture the image I had in my mind.

Escalator

Taking pictures from a moving escalator tests your reflexes along with how well you know your equipment. You have to react as soon as you see a potential subject or composition. You're moving and they're moving, which means that perspective and distance are constantly changing. When I saw just one person coming down the escalator, I knew the potential was there for an interesting photo. Most of the time there are multiple people on the escalator. With multiple people it makes it harder for everything to "come together" just right. A single person made things simpler. I raised my camera, tilted the Composer to the left, and focused as quickly as possible. I got off two shots and in one the focus landed in the right spot. No time to fumble with buttons, dials, or my Lensbaby. Being able to intuitively use your equipment will give you a better chance at capturing fleeting moments.

Ferris Wheel
Lensbaby Composer, Plastic Optic, f/4

Escalator

Lensbaby Composer, Double Glass Optic, f/4

Fisherman

This fisherman was preparing bait for the next morning. There wasn't posing; I was on the boat photographing him as he was working. His hands were moving quickly, so I captured a burst of shots; then, when I edited the photos, I decided which had the best hand position to illustrate what he was doing. Composition and placement of the sweet spot were also important to the overall success of the images. I used a vertical format for a tight composition that focused attention on the subject and the bait line. This helped avoid elements in the background that could be distracting. I placed the sweet spot in the lower part of the frame because I wanted the photo to be about the work the subject was doing. The blurring of the upper body keeps the attention squarely on the activity of the hands.

Bees

Only a small part of the photo is in focus, but the Lensbaby can't take all the credit for that wonderful blur. I got a little help from Mother Nature. It was late in the day and starting to get dark. The wind was whipping through the garden, and I used that to my advantage. I set my ISO to 100 and determined that a proper exposure would be 10 seconds. Then I waited until a good gust of wind was coming through and started the exposure. The wind did its job and helped further blur the plants around the colorful bees. It made the

Fisherman
Lensbaby Composer, Plastic Optic, f/4

biggest difference behind the orange bee, where, even with the Lensbaby's shallow depth of field, it was still fairly distinct. So, if the wind took care of blurring all those plants, could I have gotten the same shot with a regular lens? Definitely not. The Lensbaby was still invaluable for blurring the bees.

Bees

Lensbaby Composer, Double Glass Optic, f/4

Best Optic for the Job

When I'm considering which optic to use for a particular subject, there are a couple things I'll think about. First, is there a specific effect I want to create? Second, does the subject itself dictate which optic would be best?

Storefront

For the photo of the storefront with holiday lights, it was about creating a specific look. As I walked past rows of shops in the evening, I envisioned a scene that had an ultra-dreamy look in which the lights were large glowing orbs. The feeling of the photograph would be warm, cozy, and inviting. With this in mind I began looking for a subject. Knowing the type of scene I wanted to capture helped focus my attention as I kept an eye out for the right kind of display of lights. When I saw this store, I knew there was potential—lots of colors to work with and a good arrangement of lights. The optic of choice was Plastic to give me as much of the soft, dreamy look as possible. I composed the image to use the strands of lights as repeating frames, the outer strands framing the whole scene and the inner strands framing the doors. With the sweet spot on the door, the attention stays on the center of the image and what might be inside the store.

Grasses

There's a lot of detail in this cluster of grasses—detail that could visually dominate the picture. I didn't want attention to be placed on each strand of grass but instead on the overall flow of the grasses and the way they're leaning and arching from left to right, reaching across the image. To soften the details but not have heavy blurring, I turned to the Soft Focus Optic. For maximum softness I was also using the soft focus aperture with the largest center hole. The most challenging part of photographing the grasses was finding the best perspective. Wanting to have an overall flow in the direction of the grass, I paid careful attention to the lines of the grasses and how they were moving through the picture. Were they uniform in direction or were they chaotic, leading the eye in different directions? I also paid heed to what was happening in the background, not wanting anything to draw attention away from the primary grasses in the foreground. After spending a while going round and round tufts of grasses, exploring various perspectives and compositions, I found one cluster where everything came together.

Storefront
Lensbaby Composer, Plastic Optic, f/4

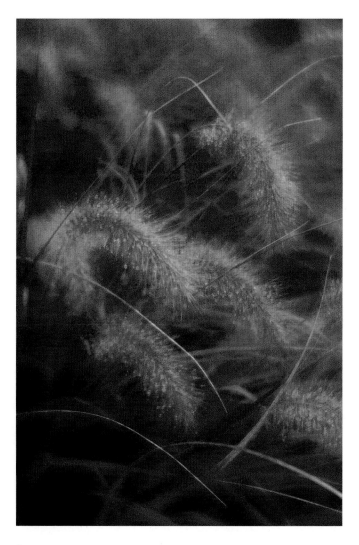

Grasses
Lensbaby Composer, Soft Focus Optic, soft focus aperture
disc: large center hole

Street Rod

I spent an afternoon photographing street
rods on the boardwalk in Ocean City, New
Jersey. With their colorful paint jobs and
varied designs, there were abundant details to
explore. Another one of my photos from that
day is in my portfolio that follows Chapter 1.
The fine detail and texture drew me to the grille
of this car. I use the Double Glass Optic because
I wanted the texture to jump out at the viewer,
grabbing their attention. I moved in close
enough to fill the frame with the grille and cre-
ate a symmetrical composition. It's essentially
an image about lines. The pattern of the bars
became a secondary element, a backdrop for
the Chevrolet nameplate. Aside from the sharp-
ness of the Double Glass, its sweet spot was
a key element to making the photo a success.
The blur at the edges of the sweet spot makes
the bars look like they're fading away. Shooting
handheld, I took a series of shots, tweaking the
focus each time to make sure I got at least one
with the Chevrolet name tack-sharp.

Cotton Grass

My selection of the Single Glass Optic for pho-
tographing this cotton grass scene was for the
sole purpose of trying to capture a flare effect.
I knew the Single Glass was more likely than the
Double Glass to produce flare because its glass
element is uncoated. The late afternoon light

Street Rod
Lensbaby Composer, Double Glass Optic, f/4

Cotton Grass

Lensbaby Composer, Single Glass Optic, f/2 (no aperture disc)

gave a dramatic glow to the cotton grass. Pointing the camera toward the backlit scene, I saw a wash of rainbow colors in my viewfinder. Flare! It worked out perfectly for the scene, like a rainbow starburst reaching down into the photograph. I tilted the camera down just enough to keep the sun and surrounding bright sky out of the shot. Even without the light source in the photo, it still was intense enough to create the flare. The Single Glass also gave me a slightly dreamy look, due in part to a happy accident. In my rush to switch to the Single Glass Optic, I forgot to take the aperture disc from the Double Glass. I was unknowingly shooting without an aperture disc; in my mind I had the f/4 disc in the optic. It wasn't until later, when I was reviewing the photos and trying to figure out why they were "extra" dreamy looking, that I realized what had happened.

Lamppost

Looking at a fairly plain street scene, I was interested in creating an image with an ominous mood. Along with the time of day, I thought the Fisheye Optic could help with that—give the scene a bit of an edge, transform it. What better way to transform a scene than use an optic that produces significant distortion! As I looked at the scene through my viewfinder, I was watching how a number of elements came together. The key pieces

in the image were the two street lamps, the house, and the tall bare trees behind the house. I first moved in close to the near lamppost to make it the most prominent element, an anchor for the composition. The Fisheye distortion was helpful in bending the lamppost to follow the curved edge of the image. This also worked to frame the house. Watching the details, I took care to position myself so that the lamppost didn't block the doorway. The far lamp and the trees became supporting elements. The second lamp was included to create a connection between foreground and background as well as to draw the viewer's eye into the image. The bare trees were able to be place between the lamps, helping to fill the overcast sky. All in all, I was able to find a perspective that positioned the key elements for the greatest impact.

Traffic Trails

Timing was one of the most important and challenging elements in creating this photograph. Before we get to the timing part, let me tell you why I was looking down on the highway. I was in search of suitable subject matter for experimenting with the Zone Plate Optic. In particular, I wanted to play with the Zone Plate's special effect of turning light sources into bursts made up of concentric circles. Shooting from a pedestrian walkway,

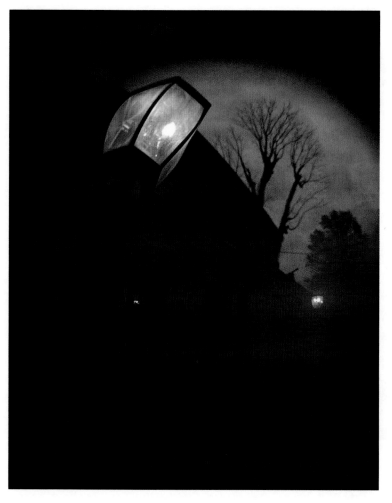

Lamppost
Lensbaby Composer, 12 mm Fisheye Optic, f/4

I positioned the Lensbaby to shoot through an opening in the fencing that enclosed the walkway. The Zone Plate did its magic, and the lights along the highway created a band of concentric circles filling the night sky. The key to recording the streaks of headlights and tail-lights was a long exposure (13 seconds), plus having enough cars drive by during the exposure. It was a bit of trial and error as I tried to capture images in which both sides of the road were filled with streaks of light. I would wait until it looked like there were a bunch of cars coming in both directions. Then I'd trip the shutter and hope there ended up being enough traffic volume on both sides to create the large bands of color. Even though I knew what conditions to look for, it still took a number of attempts to get everything to come together just right. There weren't a lot of cars on the highway that night, so more time was spent waiting than taking pictures. When you're not sure exactly what you're going to get, it's a good idea to capture a number of variations and choose the best one(s) later. This set-up yielded a couple of keepers. This particular exposure stood out because the yellow dashes among the red give it a different look.

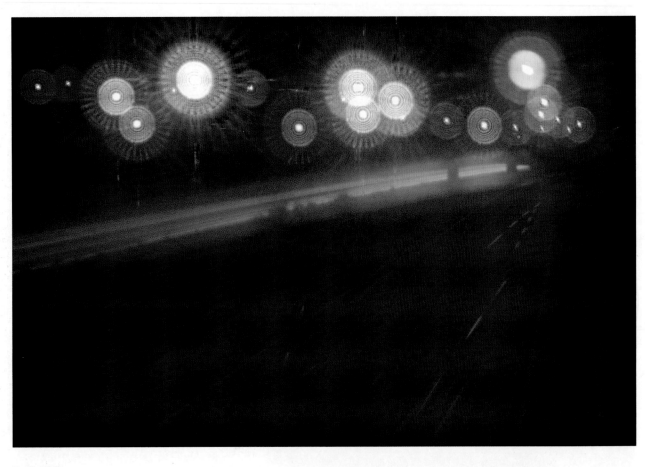

Traffic Trails
Lensbaby Composer, Zone Plate Optic

URBAN DETAILS & ARCHITECTURE

URBAN LIFESTYLE

portfolios

Jerome Hart

L. Toshio Kishiyama

Urban Details & Architecture

Jerome Hart

I am a seasoned professional photographer and have been shooting seriously since the middle 1960s. I have experience in all aspects of photography and shoot for a living every day. When I shoot for myself, the last thing I want to do is to go out and shoot something that is like a "job." I know how to light. I know how to make sharp images. I know I want to do something different that expands my knowledge base and is fun, not the same old, same old. I shoot people for a living now so I stay away from that aspect in my personal work. I am attracted to urban environments for their rich variety of color and texture. Using a Lensbaby allows me to take things way beyond simple sharpness and "correct" technique to make familiar things look different. Using unsharpness in unusual ways is what interests me now. I love going out and exploring the world with the tools that Lensbaby produces. Everything is new and magical again.

The old adage in photography is "Speak softly and carry a big camera." Been there and done that. When I shoot for fun now, I don't carry a tripod or a lot of extra gear. One body, a couple of extra cards, batteries, and one Lensbaby at a time is all I want with me. This helps me understand the unique elements of the lens I am using and to concentrate on making it work. I don't want to dilute my intensity by having too many choices. In the old days, I saw a lot of people going out to shoot with a view camera loaded with B&W as well as a Hasselblad loaded with color negative and even a 35 mm loaded with Kodachrome so they can shoot everything. They end up shooting very little of any importance because their vision is limited by their gear. Now I see a similar trend of people carrying every piece of equipment they own with them so they can be "creative" and not limited by not having the right stuff. Same result as the old days ... a person becomes a mule rather than a photographer. Vision begins and ends with "the eye." More gear doesn't help with this at all. To me, a Lensbaby is freedom and a license to look at the world in different ways. I save the heavy lifting for work and am having much more fun with a whole lot less.

To see more of Jerome Hart's photography, visit jhartphoto.com

© **Jerome Hart www.jhartphoto.com**
Lensbaby Composer, Plastic Optic, f/2 (no aperture disc)

Processed normally in Photoshop with very few adjustments.

© Jerome Hart www.jhartphoto.com
Lensbaby Composer, Soft Focus Optic, f/16, Wide Angle Lens

The camera used is a D60 Canon converted to shoot infrared. The color is as it came from the camera and very little additional processing was done in Photoshop.

© **Jerome Hart www.jhartphoto.com**
Lensbaby Composer, Double Glass Optic, f/4

Everything looks pretty much the way it was, and only slight adjustments were made in Photoshop.

© Jerome Hart www.jhartphoto.com
Lensbaby Composer, Soft Focus Optic, f/4

HDR photo: three shots two stops apart combined using Photomatix and finished with Topaz adjust. No additional equipment.

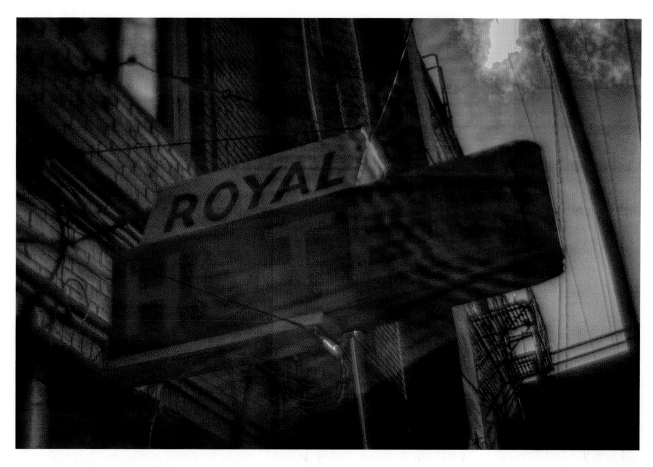

© **Jerome Hart www.jhartphoto.com**
Lensbaby Composer, Zone Plate Optic, Telephoto Lens

Very few adjustments were made and the flare is natural.

—————————————— **Urban Lifestyle** ——————————————

L. Toshio Kishiyama

The Lensbaby Composer is an incredibly fun lens and it has really expanded my photographic creativity. Its ease of use and smooth selective-focus ability provide tons of opportunities to take spontaneous and candid photos on the fly. With the Composer, I'm able to isolate the subject and really bring out the energy of the shot. As illustrated in my photos, my Lensbaby also helps me capture the mood and emotion within an image.

Even though I travel extensively, my home is in the Washington, DC, area. Creativity is sometimes challenging when trying to capture well-known landmarks in the Capital, such as the Washington Monument, that have been shot from practically every angle possible. With the Lensbaby, I've been able to get some very unique photos that stand out from the multitude of ordinary postcard shots. With a slight adjustment of the focal point, I am able to immediately capture my impression of the moment.

I often use the wide-angle adapter to bring in as much of the scene as possible. The f/4 aperture disc is probably my favorite. It provides me with just the right amount of selective focus while keeping the background readily identifiable. For macro shots, I enjoy using the close-up filters. The close-up filters are particularly handy for butterfly and flower macro photos.

Overall, my Lensbaby is my most enjoyable lens. Photo editing software can come somewhat close to duplicating the selective blur, but it is not nearly as much fun. There is just something about being at an event or a location and capturing the scene, and your vision, on the spot.

My Lensbaby photo tips for people and urban scenes:

1. *Focus on the subject.* The Lensbaby is perfect for selectively focusing on and isolating the subject, whether the person is in a crowd or standing alone.

2. *Try black and white.* While colorful shots bring out energy, black-and-white Lensbaby images can bring out the strong emotion of the moment. Black-and-white Lensbaby shots can also bring about a timeless image quality.

3. *Get creative.* Probably the best feature of the Lensbaby is that it provides the ability to get really creative and to get amazingly unique shots. Do not hesitate to experiment and take lots and lots of photos.

To see more of L. Toshio Kishiyama's photography, visit flickr.com/photos/toshio1

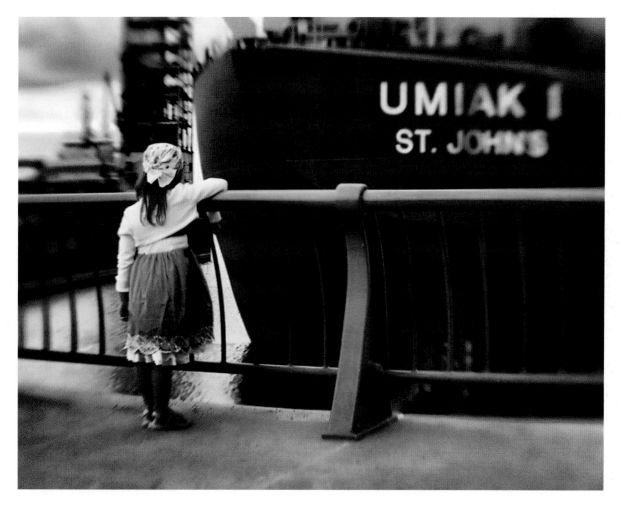

© **L. Toshio Kishiyama**
Lensbaby Composer, Double Glass Optic, Wide Angle Lens

When this little girl, in her colorful outfit, stopped to watch the ship at the Port in Old Montreal, I knew I had to capture the moment. She seemed to be saying goodbye to her father the sailor as she gazed at the stern of the vessel.

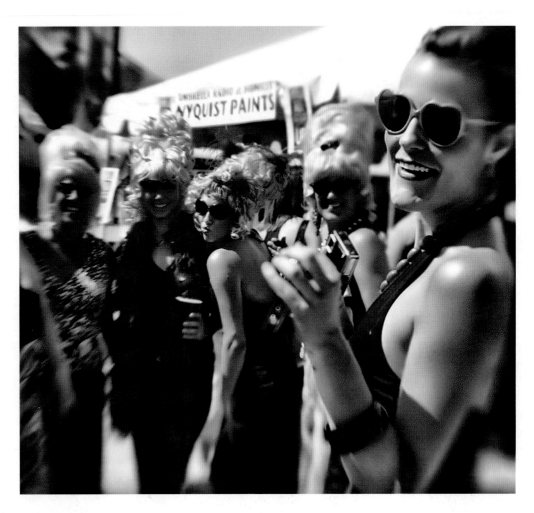

© **L. Toshio Kishiyama**
Lensbaby Composer, Double Glass Optic

The Baltimore Hon Festival is a celebration of the hard-working women in Baltimore, Maryland. Bright beehive hairdos, big colorful glasses, and '50s-style dresses rule the day. My aim here was capture the festive mood of the celebration.

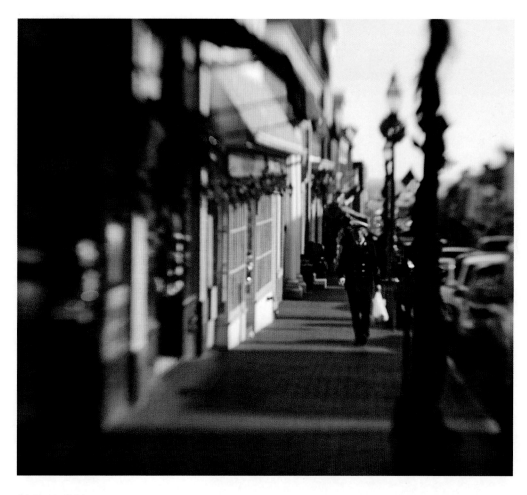

© **L. Toshio Kishiyama**
Lensbaby Composer, Double Glass Optic

The City of Annapolis is the home of the U.S. Naval Academy, so I wanted to capture both the historic Main Street of Annapolis as well as the cadet strolling through the historic district. My Lensbaby Composer allowed me to place the focal point on the cadet while bringing in the festive holiday and historical atmosphere.

© **L. Toshio Kishiyama**
Lensbaby Composer, Double Glass Optic, Wide Angle Lens

It was a cold, wintery day on the National Mall in Washington, DC, when I snapped this photo. My Lensbaby Composer allowed me to capture the emotion of the moment while keeping the Washington Monument and the people below in focus.

© **L. Toshio Kishiyama**
Lensbaby Composer, Double Glass Optic, Wide Angle Lens

The timelessness of the scene, which included the 1920s-style bonnet and regal columns in the Lincoln Memorial in Washington, DC, is the key factor that drew me into taking this shot.

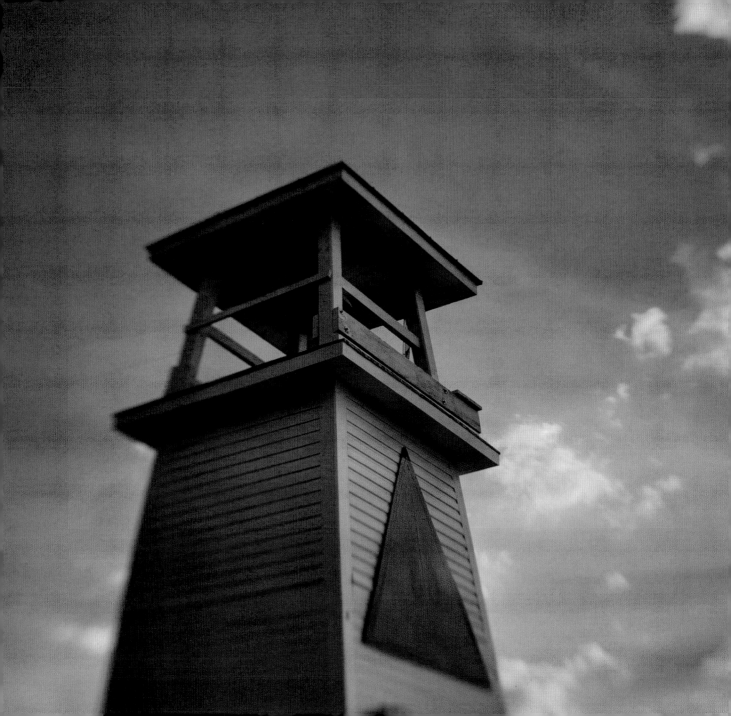

CREATIVE IDEAS

This is where your creativity comes into play. You now know about all the lenses, optics, and accessories. Apply them to anything you photograph in whatever manner you can imagine. Experiment! Have fun! So much about using the Lensbaby involves being creative. Creativity can be found in how you frame your photograph, the perspective that you shoot from, and how you use the light. Even though the Lensbaby offers many creative possibilities in such a little package, don't forget about techniques or equipment you use when photographing with your "regular" lenses. Here are some ideas about what you can use with your Lensbaby photography. Many are techniques I use regularly for other types of photography, and I've simply applied them to the Lensbaby. You've probably got your own favorite tools and techniques—just don't forget about them when you bring out the Lensbaby.

Overlays

Overlays are another technique I use for non-Lensbaby photography. The concept of an overlay involves taking two photographs and blending them together (in camera or with software) by adjusting the opacity of one or both images. For Lensbaby and non-Lensbaby photography, I often use this technique to combine two photos of the same composition; one is in focus and the other out of focus. First I take a regular Lensbaby photo: one that's sharp where I want it, has good composition, and so on.

For the second photo, I keep the composition and exposure exactly the same but turn the focusing ring to defocus the image. In choosing how much to defocus the image, I still want to maintain the general form and shape of the subject or scene. Experiment with different amounts of defocusing to see what you like.

The result of combining these two photos is a glowing edge around the sharp elements in the photo.

When defocusing my Lensbaby, I've noticed that sometimes an unusual distortion appears; this can be a cool effect with overlays. In the out-of-focus image there is a ring of distortion around the part of the photo that was in focus.

I think this stems from the Lensbaby's sweet spot of focus. As a result it might not occur when you use optics that don't have a sweet spot (Soft Focus, Pinhole/Zone Plate, Fisheye). It doesn't happen every time I defocus the image.

Combining the streaking from the sharp photo and the distortion ring from the defocused photo creates a burst or explosion-like effect around the sharp area. Since the effect is quite noticeable in the overlay, it'll be pretty clear whether an image benefits from it or not.

I usually combine the two photos using my Nikon camera's Image Overlay function. For the two selected photos, I reduce the number below each thumbnail to X0.5. This evenly blends the

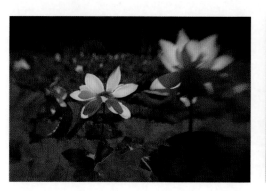

Regular Lensbaby photo (Lensbaby 3G [double glass], f/4)

Defocused photo (same composition); elements in the photo expand when they are out of focus

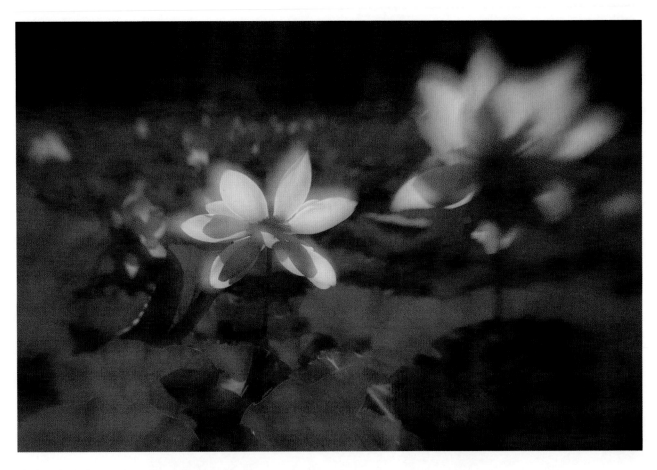

Final overlay: In-focus and out-of-focus photos combined

In-focus image (Lensbaby 3G [double glass], f/4)

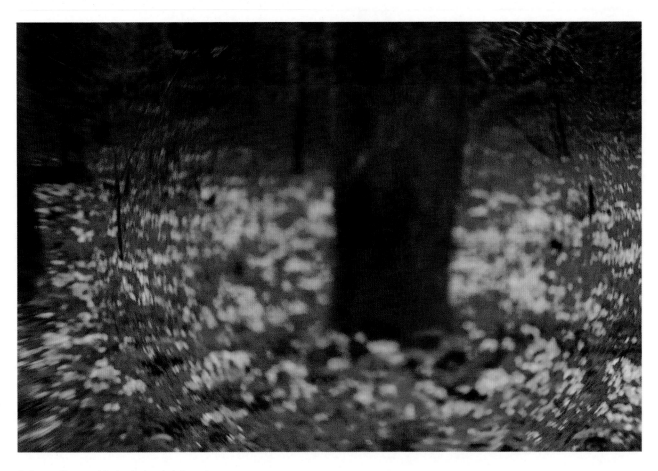

Defocused image with circular band of distortion

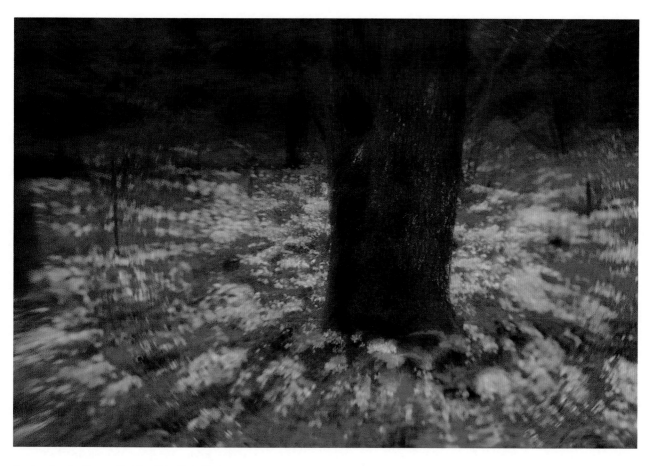

Overlay showing the result of the distortion effect

Image Overlay menu option on Nikon cameras

Opacity adjustment in Photoshop's Layers Panel

photos together. You can only use files in the Raw file format for in-camera overlays. If you have a Nikon camera, check your manual to see if you have the Image Overlay function. You'll find it in either the Retouch or the Shooting Menu.

The same result can easily be achieved in Photoshop or Photoshop Elements by making an opacity adjustment. It just takes a few steps:

1. You want to have both images as separate layers in the same file. Open both photos, then make the defocused one the active window.

2. Go to **Select > All**, then **Edit > Copy**.

3. Switch to the sharp photo and choose **Edit > Paste**. Now you have each photo as a separate layer in the Layers Panel.

4. Select the top layer and reduce the Opacity to blend the sharp photo with the out-of-focus one. I find 50 to 60% works well.

Multiple Exposures

Multiple exposures is a technique that blends a number of photos (exposures) together. I first started doing multiple exposures with a film camera. With film, you simply wouldn't advance the film between exposures, causing multiple images to be recorded on the same piece of film. With digital cameras, you still take the multiple photos, but the images are blended together by the camera or using software to create the multiple exposure.

Lensbaby Composer, Plastic Optic, f/4
Multiple exposure created by slight upward movement. The Lensbaby's sweet spot is still apparent, with the center of the image being more distinct than the edges.

I use multiple exposures to create photographs that have an impressionistic quality and convey a sense of movement. Multiple exposures retain something of the shape and form of the subject. I have an in-camera multiple exposure function on my Nikon camera, which allows me to select 2 to 10 exposures (set Auto Gain to On). I usually choose 9 or 10 exposures. Each image is properly exposed (as though it were going to be a regular photo). I take the selected number of photos in succession, then the camera blends the images together and saves only the final combined image on my memory card.

The impressionistic look is created by moving the camera between (not during) each exposure. For flexibility and ease of camera movement, I shoot them handheld. Even though these multiple-exposure photos have a significant sense of movement, the camera is actually moved very little between shots. So, how do you move it? Well, that's the fun part. Try moving the camera up and down or rotate the camera. See which effect works best for your subject. The more the camera is moved between exposures, the more abstract the final image. Move the camera less to retain more of the form of the subject. Try the same shot at least a few times, because no two multiple exposures will be the same.

Many Nikon cameras have a multiple exposure function, but not all do, so check your manual. There is also some variation on how many multiple exposures each camera can do. Other camera models may offer multiple exposure functionality, so check your manual to see.

Lensbaby Composer, Soft Focus Optic, soft focus aperture disc: large center hole

Create multiple exposures with a circular movement by rotating the camera a small amount between shots. Notice how everything here rotates around the flower in the bottom right. For each exposure I kept the flower in the same place in the viewfinder, causing it to be the center of the rotation.

If you're not able to do multiple exposures in camera, they can also be created using Photoshop. You take the photos in the same manner: each one properly exposed, moving the camera between photos. Photoshop is used simply to blend the images together. Because there are a number of steps in this process, I don't have room to detail them in the book, but you can go to the following page on my website for step-by-step instructions: coreyhilz.com/lensbaby_tutorial.html

Lensbaby Composer, Double Glass Optic, f/4

Small up and down movements create a slightly "shaken" look.

Filters

If you use filters when photographing with other lenses, don't forget about them when you put on your Lensbaby. You can use 52 mm filters with the Step-Up/Shade (see Chapter 3, Accessories section). If you have larger filters, you can try handholding them, but keep them flush with the front of the lens to avoid light bouncing around between the filter and the optic. This is easiest to do with the Composer since you don't have to hold the lens in place. It's a lot more difficult with the Muse/2.0/Original because you have to bend and hold the lens while holding the filter. The rods of the Control Freak/3G may prevent you from placing a filter right in front of the lens. In this case, cup your hands around the gap between the filter and the lens to block extraneous light (most easily done with the camera on a tripod).

Polarizer

A polarizer is a big help if you're photographing outside and you want to darken blue skies. It'll have the greatest effect if you're photographing at 90 degrees to the sun (that is, the sun is directly to your left or right). It's also useful for reducing or eliminating glare and reflections that can intensify the colors in your image.

No polarizer

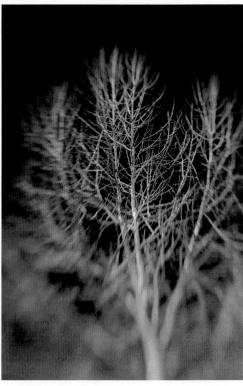

Lensbaby Composer, Double Glass Optic, f/4, Step-Up/ Shade, polarizer

The darkening of the blue sky by the polarizer has better defined the branches, especially in the lower portion, where they aren't as noticeable in the unpolarized version.

Neutral Density

A neutral density filter is useful if your shutter speed is too fast. Since I often use the f/4 aperture disc, I frequently end up with fast shutter speeds. But what if I want to use a slower shutter speed to purposely blur a moving subject? I could use a smaller aperture disc, but that would also change the depth of field and the look of my Lensbaby photo. Using a neutral density filter instead allows me to keep the wide aperture and still achieve a slow shutter speed.

Graduated Neutral Density

If you use graduated neutral density filters (grad NDs), you can also handhold them in front of your Lensbaby. The Lensbaby gives a unique look, but it doesn't eliminate problems with capturing a scene with a bright sky and dark foreground. Grad NDs are easiest to use with the Composer because the lens will stay in place and you can hold the filter flush against the front of the lens.

These are just a few examples of filters you can use. The idea is to experiment with the filters you've got, or try new ones!

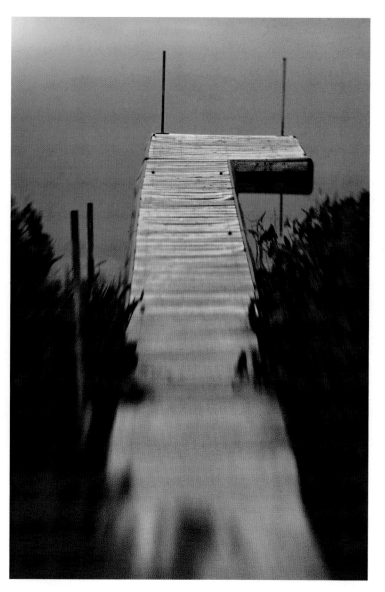

Lensbaby 3G (double glass), f/4, neutral density filter handheld

I took this photo with the 3G before the Step-Up/Shade was available. I handheld a neutral density filter to achieve a slower shutter speed that allowed the water to render as a smooth wash of color.

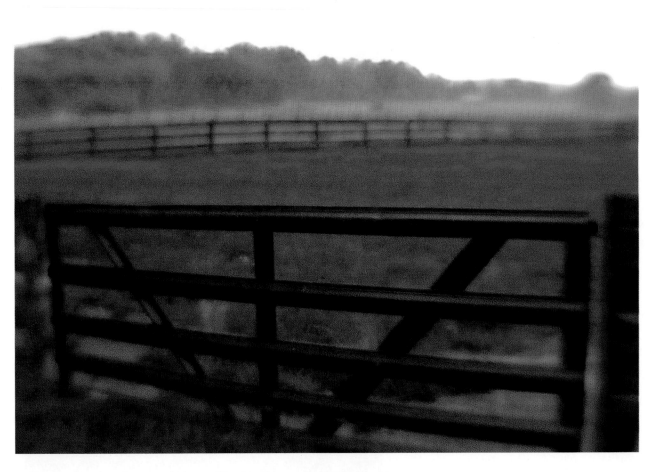

No filter: the sky and tree line are washed out, making the upper part of the image distracting

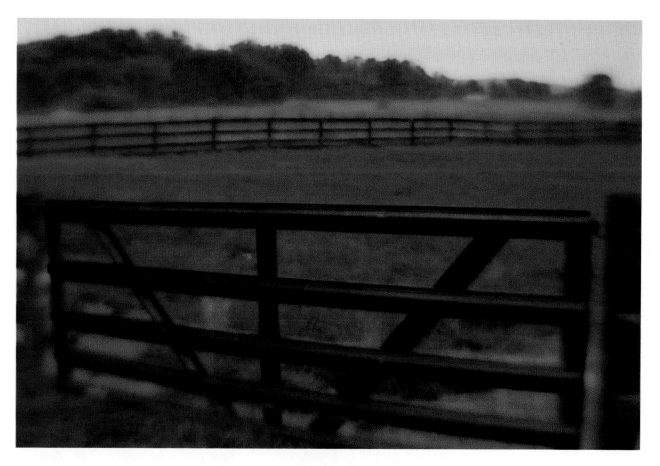

Lensbaby Composer, Single Glass Optic, f/4, Wide-Angle Lens, graduated neutral density filter, handheld

Using a grad ND to darken the sky and trees balances the brightness of the foreground and background areas.

HDR (High Dynamic Range)

When you have a subject or scene with a lot of contrast, it might not be possible to record all the highlight and shadow detail in one image. Either the brightest parts of the image look good or the darkest parts do, depending on the exposure for the photo. In some cases you could use the graduated neutral density filters mentioned in the previous section. However, when the brightest and darkest areas are not neatly separated into sky and land, a grad ND won't get the job done.

Creating a high dynamic range (HDR) image is the solution to capture the entire dynamic range of the photo. You'll want to shoot a series of bracketed exposures, then combine them to create the HDR photo. The exposures recorded in the bracketed set should be broad enough so that the darkest exposure retained all the

Six exposures were needed to capture detail from the lightest to the darkest parts of the scene

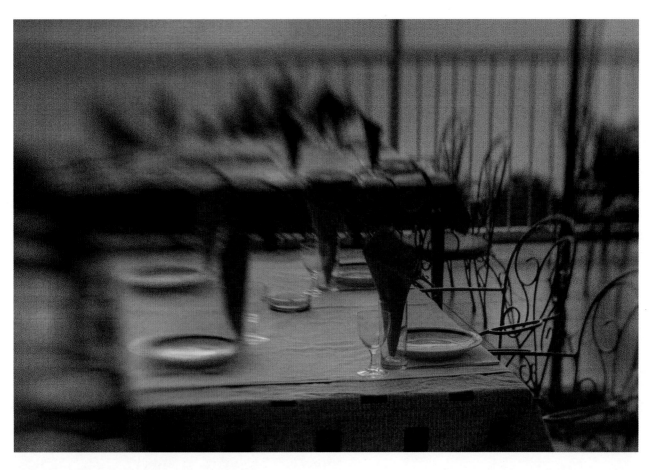

Lensbaby Composer, Double Glass Optic, f/4

The intense light on the horizon and the soft light on the tables made it impossible to record all the detail in a single exposure. HDR allowed me to capture what I saw with my eyes.

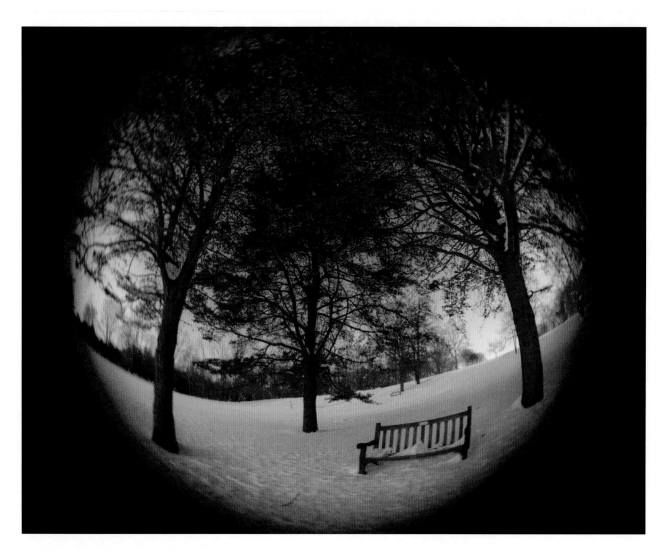

Lensbaby Composer, 12 mm Fisheye Optic, f/4

As the sun was setting, the trees above me were in the shade, with a bright blue sky behind them and the last light of the day illuminating the trees up the hill. HDR made it possible to retain good detail in all areas.

highlight detail and the lightest exposure captured all the shadow detail. Generally speaking, an exposure range of five stops will often achieve this look. Depending on the bracketing options for your camera, you can do this with five exposures set one stop apart or three exposures taken two stops apart.

If something in your photo moves between exposures, it can create a problem when the exposures are combined. Lensbaby HDR gives you a little "wiggle room" if there is movement, so long as it's not in the sweet spot. If something moves that's out of focus, it's less likely to create a problem in the final HDR image, or it's one that can be more easily fixed. I use the software Photomatix Pro to combine my exposures into an HDR image, then fine-tune the image using Photoshop.

This section is not intended to be a detailed tutorial about HDR photography but rather a suggestion of a technique that can be used with Lensbaby photos as well as your other photography. If you'd like to learn more about HDR, I'd recommend picking up a book devoted to HDR or looking online for tutorials. I've found that HDR works just as well with Lensbaby photos as it does with regular photos. If you're already shooting HDR images, the process is exactly the same.

Black and White

Try out your photos in black and white! If you find that you primarily photograph in color, try some B&W with your Lensbaby. The simplest way to capture a black-and-white image is to set your camera to shoot in a Grayscale mode. Although this makes things easy, it doesn't give you much control over the color- to black-and-white conversion. I prefer to capture the image in color, then convert it using software. Converting photos yourself gives you more options and control, which leads to higher-quality black-and-white images. Applications such as Photoshop, Photoshop Elements, Lightroom®, and Aperture® have the ability to do black-and-white conversions. If you'd like more conversion options than these programs offer on their own, try a plug-in such as Nik Software's Silver Efex Pro.

Consider how you view the color and B&W versions of this photo.

In the color version, the blue of the bicycles and the red/orange of the ground command a lot of attention. When the photo is in B&W, the viewer pays more attention to the pattern of the bicycles and their shadows.

What's Really B&W and What's Color?

If you selected just the Raw format, all that is actually black and white is the JPEG thumbnail, which is what you see when you play back your photos. If you are shooting Raw+JPEG, the JPEG file on your memory card is black and white.

Lensbaby Composer, Double Glass Optic, f/4

Converted to black and white

© **John Barclay**
blog.barclayphoto.com

Lensbaby Composer, Double Glass Optic, f/5.6, Super Wide Angle Lens

Forest Haven is an abandoned Asylum in Maryland where horrific things were done to the patients, leading to its closing. This scene screamed to be shot with the Lensbaby, which I felt added to the feeling of the building's decay and haunted past. Being in a small room made using the Super Wide Angle lens critical, allowing me to include all the necessary elements in the scene.

© **Luca Lacche**
lucalacchephotography.net

Lensbaby Composer, Plastic Optic, f/4

The subject is a rather common view in our old historical towns. As usual in my experience, I don't ever "plan" a photo; on the contrary, I try not to think much when shooting. I prefer to let the eye and the mind run free and let instinct take care of the composition. The atmosphere and mood of the place are the key for choosing that certain subject at that particular moment and seeing it in that particular way using that particular angle. Elaboration comes "after," in raw processing; that's when I set the light, format, etc. Then in CS2 I add the final details such as film grain and tone. In any case I remain close to the basic concept of photography; in fact, I intend my workflow as the digital version of the traditional darkroom, and I think full-frame D-SLRs are taking us very close to the film world.

If you're more comfortable with color photography, one of the challenges of photographing for black and white is "seeing" in black and white. You might like to see the image in black and white right when you shoot it. For this reason, the in-camera Grayscale option can be appealing. Luckily, there is a way you can get the best of both worlds: Use the Grayscale mode, yet still convert the image to black and white yourself. All you need to do is use an Image Quality setting of Raw or Raw+JPEG (in addition to setting your camera to Grayscale). The key to this trick is recording a Raw file, because Raw files still keep the color information, even if you are in the Grayscale mode. Now when you take a photo, the image on your LCD screen will be black and white, but when you view the Raw file on your computer it will be in color. Pretty neat! You'll then use the Raw file for your black-and-white conversion.

To see more B&W photos, check out the portfolios in this book, which contain a variety of examples.

Flash

When available light isn't enough or isn't quite what you're looking for, throw in some flash with your Lensbaby. In addition to using your flash as your primary light source, try using it as fill light. Reduce the power of the flash, to have it supplement the available light. Try out your flash with your Lensbaby before you need it. With some cameras the flash won't fire in the default mode (called TTL), because the camera cannot communicate with the Lensbaby. If this happens, try changing the flash mode to manual. This is true for both built-in (pop-up) flash and external flash units. When the flash is in manual mode, you have to choose the power of the flash (in TTL, the camera sets the flash power). You'll probably need to take some test shots at different power levels to determine the correct amount.

Video

Lensbaby makes versions of the Muse and the 3G that are designed to work with motion-picture cameras. That's pretty cool for film-makers, but you don't have to have your own movie camera to create Lensbaby videos. High-definition video has become a more common feature on SLR cameras. If your camera can record video, give it a try using your Lensbaby. Just as the Lensbaby gives a unique look to your photos, it can do the same for video.

Lensbaby Composer, Soft Focus Optic, soft focus aperture disc: large center hole

Photographing at night on Halloween didn't offer much available light. There was only a little light from a nearby lamp shining on the subject. I needed to use my flash but wanted the additional light to be subtle. I set the flash compensation to –2, to just add a little fill light. Also, the subject was wearing glasses, which I didn't know before taking the picture. Flash can produce unwanted reflections on glasses, but this time the reflection turned out to be a happy accident. Instead of being a single spot, the reflection is a burst-like design, because I was using a soft focus aperture disc.

Lensbaby Composer, 12 mm Fisheye Optic, f/22

With the Fisheye's extra wide view I was almost below the sign when I took this photo. I kept moving closer and closer and closer until I got it all the way across the viewfinder. I was down on the ground to capture the perspective of the sign towering over me, this also helped avoid merging the sign with the building beyond. I shot this as a static 10-shot multiple exposure, in order to belnd a series of taillights moving through the intersection. I darkened the area around the image, except for two small strips of flare at the top and bottom for balance and subtle framing.

WAIT! THERE'S MORE!
portfolios

Wait! There's More!

The other portfolios in this book offer a look into specific categories of photographs. But of course there is so much more you can photograph with a Lensbaby: athletes, insects, cars, dogs, even corkscrews! The following photographs offer different perspectives, subjects, and styles than we've seen in the other portfolios.

Learn from the insights offered by the photographers in the captions. The photographers' websites are noted with their photos; check them out to see more of their wonderful images.

© **Axel Heimken**
axelheimken.de

Lensbaby 2.0 (double glass), f/2 (no aperture disc)

The idea was to capture all runners in a row shortly after the start and to capture the explosive moment when the athletes accelerate to top speed. The "trick" is to be very close to the track and get a position right beside the lines where the athletes are running. You also have to prefocus because you will not be able to focus a Lensbaby that fast when the runners pass.

© **Lisa Smith**
LisaSmithStudios.com

Lensbaby 3G (double glass), f/2.8, Wide Angle Lens

Well, three things drew me there. One, I was out pho-
tographing with my dad, exploring the area he had just
moved to, and it's on the main road out there. His name is
Paul, so I knew at some point it had to be photographed.
Two, it was grungy and crusty and I love grungy crusty
retro things. Three, it had great potential for lens flare
with one streetlight near it. So I said "Errrrrrt! Stop the
car!" I was teaching my dad lens flare tricks that night.
I used the 3G Lensbaby and it was a little dirty (adds some
grunginess to the flare ring). :-) When you position the
light source just on the outside edge of the frame, you
get an amazing ring of flare. If you position yourself just
right you can frame other objects in the scene with the
ring of flare, which makes for a killer composition. I love
lens flare!

© **Michael Koerner**

michaelkoernerphotography.com

Lensbaby 3G (double glass), f/2

I shot the image into the sun. It was late in the afternoon, which gave the long shadows and definition that I like. I was hoping to get some nice lens flare from the Lensbaby lens on this shot, to go along with the silky blur that often occurs from this type of lighting.

© **Joye Ardyn Durham**
artistwithcamera.com

Lensbaby Composer, 12 mm Fisheye Optic, f/16

After the capture I used Topaz Adjust in Photoshop CS3 to get the grunge effect. I love using this lens for canine portraits because you can get very close to the nose—if the dog doesn't mind—and you can really get some interesting expressions. This shot is of my 13-year-old Siberian Husky mix named Juneau. She is not only a good model, she can also sing Happy Birthday! The close-up capabilities of the Fisheye are incredible whether you're shooting portraits or nature. It is my favorite lens.

© **Craig Strong**
strongphoto.com

Lensbaby 3G (double glass), f/4

This is one of the few images that I have been able to envision exactly the way I captured it. I saw my son throwing rocks from a distance. Rock throwing was one of his favorite things that summer. As I approached I unlocked my 3G and quietly slipped down on my knees behind him, to put the horizon about a third of the way down from the top of the image. I was only able to make one frame before he got up and walked away.

© **John Barclay**

blog.barclayphoto.com

Lensbaby 3G (double glass), f/5.6

The image was made inside one of the preserved buildings at Bodie State Park in California. As an amateur musician, I was drawn to the open book of music and felt the Lensbaby was a perfect choice, helping to evoke a sense of nostalgia.

© **Stacey Shackford**

staceyshackford.com

Original Lensbaby (single glass), f/2.8, +4 and +10 Macro Filters, stacked

One thing I love about the Lensbaby is its sometimes unpredictable super-saturated color and how the Macro Kit can transform otherwise mundane objects into abstract wonders. This close-up was taken in my kitchen as I hovered above a blue-handled corkscrew until it came into focus—my preferred technique when using the Lensbaby macro lenses.

© **Mark Cornelison**
markcornelison.com

Lensbaby 2.0 (double glass), f/5.6

This image of homemade French dressing was shot for a cookbook called *Flavors of Kentucky*. It was my first time shooting a cookbook, and this image was shot on the first day I had a Lensbaby. I could not believe the sharpness that can be achieved. I think this image does everything a Lensbaby is supposed to do: It takes a fairly basic, maybe even boring, subject in a normal setting (a kitchen) and makes it an image that suddenly becomes something to look at. The cookbook was very successful and because of the book, with full credit going to the Lensbaby 2.0, I have been commissioned to shoot another cookbook because the client loved the look of the photos. Suddenly I am a food photographer! Who knew!?

© **Kathleen Clemons**
kathleenclemons.com

Lensbaby 2.0 (double glass), f/2.8, +4 Macro Filter

I shot this aged coneflower one gray and cold November morning here in Maine. I was drawn to its resilient beauty and petal lines.

© **Sergej Karssen**
sergej.karssen@gmail.com

Lensbaby 3G (double glass), earlier Macro Filter equivalent to stacking +4 and +10

Typically, when shooting macro with the 3G, I extrude it to its full length, lock it in place, and focus by moving the camera closer to the subject. What I love about this image is the red and green tones and the catchlights in the spider's eyes. If you look closely, you can see the photographer at work reflected in this little predator's eyes.

© **Oliver Tudoras**

olivertudorasphoto.com

Original Lensbaby (single glass), f/4

As a social worker, I'm very interested in people's stories ... that's why I took this image of Miss Ruis's hands. She is a very religious woman and she really needs her beliefs to survive. She loves to tell stories from the past, and she loves her old rosary.

TROUBLESHOOTING AND COMMON QUESTIONS

What's Going On with My Lensbaby?

Here are some common issues and questions about using a Lensbaby. Most of these topics are detailed elsewhere in the book, so in this chapter I've included brief answers, then noted where to go for more information.

Camera Compatibility

Lensbabies are compatible with SLRs made by the Nikon, Canon, Sony, Pentax, and 4/3 mount cameras. When you purchase your lens, just make sure you get one with the correct mount for your camera.

No Aperture Number Appears on the Camera

Lensbabies don't have an aperture that the camera can control. As a result, our cameras see Lensbabies as having no aperture at all. Where an aperture number should be displayed, you'll likely see -- or 00. You can ignore it; your Lensbaby will work just fine.

More info: Chapter 2, section "Exposure and the Lensbaby"

How Do You Change the Aperture?

The aperture in a Lensbaby is controlled by a black disc that sits inside the Lensbaby. Look into your lens from the front and you'll see the aperture disc at the bottom. Lensbabies come with the f/4 disc already in the lens. To change the aperture disc, use the aperture tool that came with your Lensbaby.

More info: Chapter 2, section "Aperture Discs"

The Camera's Light Meter Doesn't Work

There is no electronic communication between the Lensbaby and your camera. For some cameras this means that the light meter will not function. If your camera won't change shutter speeds while in Aperture Priority mode, that means that the camera isn't able to use the light meter. Go to Manual Exposure mode instead, where you can change the shutter speed yourself. To find the correct shutter speed, you might need to do a series of "guess and check" test photos or take a photo with a regular lens to see what shutter speed the camera selects.

More info: Chapter 2, section "Exposure and the Lensbaby"

The Viewfinder Is Really Dark

Check to see which aperture disc is in the lens. It's probably one that has a moderate to small hole (f/8, f/11, f/16, f/22), which means that not much light is being let into the viewfinder. This causes the viewfinder to look dim or even dark, especially if you are photographing in less than bright lighting conditions. Try composing and focusing with a wider aperture, then switch to the smaller one when you're ready to take the shot.

More info: Chapter 2, section "Aperture Discs: Viewfinder Brightness"

My Photos Aren't in Focus

- Check that your diopter is set correctly; otherwise you won't be able to focus accurately.

- Are you using a fast enough shutter speed? If you use a shutter speed that's too slow, you won't be able to hold the camera/lens still. If you're photographing a moving subject, use a shutter speed that's fast enough to stop the action.

- Using the right bending and focusing technique for your Lensbaby is key to consistently capturing sharp photos.

- Make sure you aren't too close to your subject. Use the Macro Filters to get close-up shots.

More info: Chapter 2, section "Focusing and the Sweet Spot"

The Flash Won't Fire

If your flash won't fire, the mode of the flash is often the problem. Your flash is likely set to the standard flash mode, called TTL. Check your camera's menus or manual to find your flash settings and switch the flash mode to manual.

More info: Chapter 5, section "Flash"

Pinhole/Zone Plate Optic: Which Hole Is Which?

Hold the optic up to a light and look into it. Slide the switch to change from one hole to the other. The larger hole is the Zone Plate; the smaller (tiny) one is the Pinhole.

More info: Chapter 3, section "The Optic Swap System: Pinhole/Zone Plate Optic"

Lensbaby Composer, Double Glass Optic, f/4

The butterfly was staying pretty still while feeding on a fruit dish. The challenge was finding a good angle on the butterfly that also had a strong background. Everything came together when I was able to include some of the blue dish, which offered an attractive contrast to the many warm tones in the image.

COMMUNITY GALLERY
—— portfolios ——

Community Gallery

A call for submissions was held to select photographs for the Lensbaby Community Gallery. More than 1,900 photos were submitted from around the world, showing the international scope of the Lensbaby community. These images demonstrated the imagination of the photographers and their willingness to experiment with the Lensbaby. The photographers represented on the following pages are from Australia, France, Indonesia, the Philippines, the United Kingdom, and the United States. One photo for this gallery was chosen by a popular vote by members of the Lensbaby forum community: Esben Melbye's photo of the Hollywood sign. Myself and Craig Strong from Lensbaby reviewed all the entries and chose the remaining images to be included here. We were impressed by the variety of style and subject matter. The images demonstrate skill in choosing a subject, capturing the moment, and finding creative ways to use the Lensbaby. Their compositions draw the viewer in, using the Lensbaby's sweet spot and creative effects to direct attention to the key part of the photograph. Thanks to everyone who submitted images. Continue expressing your personal vision with your Lensbaby!

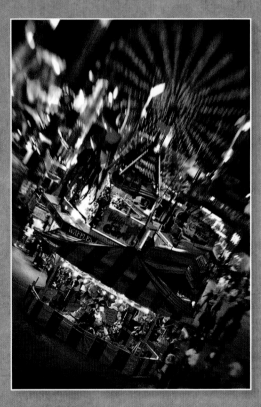

© Rich Evans
rich-evans.redbubble.com
Lensbaby Composer, Double Glass Optic, f/11

© **John Sigler, blowback photography**
blowbackcreative.com/pix

Lensbaby Composer, Double Glass Optic, f/2.8

© **Lara Jade**
larajade.co.uk

Lensbaby Muse, Double Glass Optic, f/4

© **Gary Yost**
yostopia.com
Lensbaby Composer, Double Glass Optic, f/4

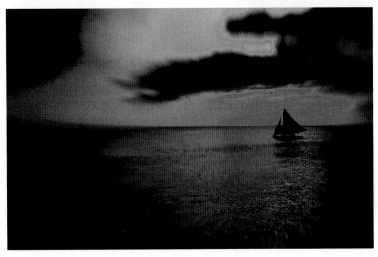

© **Tilak Hettige**
tilakhettige.com
Lensbaby 2.0 (double glass), f/2 (no aperture disc)

© **Ian Davies**
digipix76.co.uk
Lensbaby Composer, Double Glass Optic, f/4

© **Joseph G. Marotta**
joegmarotta@gmail.com
Original Lensbaby (single glass), f/2.8

© **Donny Connor**
donnyconnor.weebly.com

Lensbaby Composer, Double Glass Optic, f/2.8

© **Esben Melbye/EsbenFoto**
esbenfoto.com

Lensbaby Composer, Double Glass Optic, f/5.6

© **Mehrdad Vaghefi**
mvartphoto.com
Lensbaby 2.0 (double glass), f/2 (no aperture disc)

© **Bob Bowné**
bownephoto@optimum.net

Lensbaby Composer, Single Glass Optic, f/11, Super Wide
Angle Lens

© **David Yates**
flickr.com/photos/lumiereimages
Lensbaby 2.0 (single glass), f/2 (no aperture disc)

© **Carol Cohen**
fstopcarol.com
Lensbaby 3G (double glass), f/4, +4 Macro Filter

WRAP-UP

I hope the images throughout the book have whetted your appetite for the incredible variety of ways you can use a Lensbaby to share your creative vision. And with any luck the information has helped you become more knowledge-able about the Lensbaby and its accessories! Of course, the images in the chapters and portfolios are just a sampling of what you can do with a Lensbaby. There are so many people out there creating and experimenting with their Lensbabies; I encourage you to get involved with the Lensbaby community. Check out the Lensbaby groups on Flickr as well as the forum at Lensbaby.com. These communities are great ways to receive feedback about your photos and check out what others are doing. Seeing photos by other Lensbaby photographers can be inspirational as well as educational. And most important – have fun!

To see more of my photography, visit coreyhilz.com

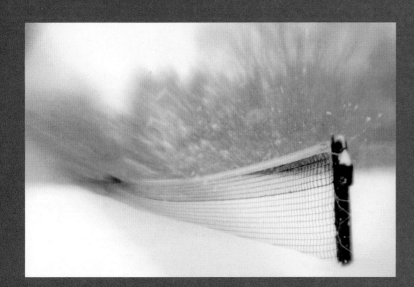

Lensbaby Composer, Plastic Optic, f/4

As soon as I looked through my viewfinder and saw the net being swept off in a blur, I knew there was a shot here. The gate to the tennis court was locked, so I settled for photographing through the fence. I experimented with different perspectives, watching how the blur would transform the net and trees beyond.

**Lensbaby Composer,
Single Glass Optic, f/4**

I had just finished
photographing the last
bit of color on the horizon
when I saw the setting
moon. I rushed around
looking for a group of
trees and a perspective
that would place the moon
near the treetops. The rich
blue of a sky at dusk can
be a great backdrop for
many types of scenes.

SUBJECT INDEX

Page numbers followed by "*f*" indicates a figure. Items in green text refer to photos in the book taken with the listed lens and optic.

A

accessories, 123
 aperture discs. *See* aperture discs
 Creative Aperture Kit, 137–138
 Custom Lens Cases, 146
 experimenting with, 162
 lenses. *See* lenses
 Macro Kit, 124–128
 optics. *See* optics
 Step-Up/Shade, 145
 Super Wide Angle Lens, 133–136
 Wide Angle/Telephoto Kit, 129–132
Adobe Photoshop
 combining multiple exposures, 213
 opacity adjustment, 210*f*
aperture, changing, 244
aperture discs, 45–54, 47*f*
 experimenting with, 163–165
 with Fisheye optic, 102
 removing and changing, 47–50, 102, 244
 with shapes. *See* Creative Aperture Kit
 Soft Focus optic, 94–97, 94*f*, 95*f*, 97*f*
 Soft Focus optic, effects with, 99
 viewfinder brightness and, 54–55, 245
aperture numbers, 29, 244
Aperture Priority mode, 28

aperture selection, 163–165
Auto/Scene mode, 28

B

B&W. *See* black-and-white images
bees, as subject, 179, 180*f*
bending (to focus), 38
 Composer lens, 8
 Fisheye optic, to change black border, 104–108, 105*f*–108*f*
 with wide angle lenses, 129
black border, creating artificially, 114
black border with Fisheye optic, 104–109
 adjusting by bending lens, 105–108, 105*f*–108*f*
black-and-white images, 196, 221–226, 222*f*, 224*f*–225*f*, 241*f*, 249–253, 249*f*, 251*f*–252*f*, 254*f*
blending exposures. *See* multiple exposures
blur, depth of field vs., 47. *See also* focus
boxes, focusing, 31
bracketing focus, 44
brightness through viewfinder, 54–55, 245

C

camera compatibility, 244
changing aperture discs, 47–50
 with Fisheye optic, 102

chromatic aberration, 84, 85
 with Super Wide Angle Lens, 135
close-up photos, tips for, 128
color flare, with Fisheye optic, 109–115, 110*f*–112*f*
color fringing. *See* chromatic aberration
combining exposures. *See* multiple exposures
commercial photography, 116
Community Gallery, 247–248
compatibility, camera, 244
Composer lens, 4*f*
 advantages of, 4
 creation of, ix
 custom lens case for, 146, 146*f*
 Fine-Focus Ring, 13, 13*f*
 focusing with, 42, 44
 summary information about, 7–8
 swapping optics, tips on, 74
Composer lens, photos taken with
 Double Glass optic, 7*f*, 19*f*, 21*f*–23*f*, 33*f*, 43*f*, 66*f*–69*f*, 173*f*, 178*f*, 180*f*, 184*f*, 193*f*, 198*f*, 199*f*, 213*f*, 246*f*, 248*f*–252*f*
 Double Glass optic (B&W photos), 222*f*, 224*f*
 Double Glass optic (shoot-through), 171*f*

Double Glass optic, high dynamic range, 219f
Double Glass optic, polarizer, 214f
Double Glass optic, Star Aperture, 141f–143f, 172f, 174f
Double Glass optic, Super Wide Angle Lens, 134f, 135f
Double Glass optic, Wide Angle Lens, 65f, 130f–132f, 197f, 200f, 201f
Fisheye optic, 16f, 101f, 103f, 109f, 112f, 155f, 187f, 234f
Fisheye optic, high dynamic range, 220f
Pinhole optic, 88f
Plastic optic, 20f, 24f, 82f, 83f, 85f, 177f, 179f, 182f, 191f, 211f, 225f
Plastic optic, Macro Filter, 128f
Plastic optic, Telephoto Lens, 170f
Single Glass optic, 18f, 46f, 80f, 185f
Single Glass optic, graduated neutral density filter, 217f
Single Glass optic, Super Wide Angle Lens, 253f
Single Glass optic, Telephoto Lens, 81f, 164f, 165f
Soft Focus optic, 93f, 98f, 99f, 156f, 159f, 183f, 194f, 212f, 227f
Soft Focus optic, Wide Angle Lens, 192f
Zone Plate optic, 92f, 188f, 195f
Zone Plate optic, Telephoto Lens, 87f
composing with Pinhole and Zone Plate optics, 88–89
Control Freak lens, 6f, 154
 advantages of, 6
 creation of, ix

custom lens case for, 146, 146f
filters with, 213
Fisheye optic with, 102
focusing with, 38–40, 44
Live View function with, 45
summary information about, 11
swapping optics, tips on, 74
Creative Aperture Kit, 137–138
 choosing subjects for, 138
 comparison of shapes, 138, 139f
 limitations of, 124
creative experimentation, 183–186
 aperture considerations, 163–165
 letting go of focus, 167
 optic selection, 173–175
 reinventing the ordinary, 173–175
 self-assignments, 162–163
 shoot-through technique, 171
 streaking effect, 165–167
 timing, 173
creative ideas, 196, 213
 B&W images. See black-and-white images
 filters, 213–221, 217f–220f
 flash, using, 226, 227f
 multiple exposures (combined), 113, 210–213
 overlays, 204–210, 206f–209f
 video, 227–229
cropping black border (Fisheye optic), 104
Custom Lens Cases, 146

D

depth of field, 42
 aperture discs and, 50–54

blur vs., 47
with Macro Filters, 126
diopter, setting, 33–35
DiVitale, Jim (portfolio), 115–116
Double Glass optic, 77–79
 aperture discs with, comparing, 51f–53f
 compared to other optics, 75f
 focus sweet spot, 31f
 various aperture discs with, 50
Double Glass optic, photos taken with
 Composer lens, 7f, 19f, 21f–23f, 33f, 43f, 66f–69f, 173f, 178f, 180f, 184f, 193f, 198f, 199f, 213f, 246f, 248f–252f
 Composer lens (B&W photos), 222f, 224f
 Composer lens (shoot-through), 171f
 Composer lens, high dynamic range, 219f
 Composer lens, Polarizer, 214f
 Composer lens, Star Aperture, 141f–143f, 172f, 174f
 Composer lens, Super Wide Angle Lens, 134f, 135f
 Composer lens, Wide Angle Lens, 65f, 130f–132f, 197f, 200f, 201f
 3G lens, 12f, 25f, 77f, 117f, 118f, 158f, 175f, 233f, 235f, 236f
 3G lens (out of focus), 168f, 169f
 3G lens (overlays), 206f–209f
 3G lens (streaking effect), 166f, 167f
 3G lens, Macro Filter, 125f, 126f, 157f, 240f, 254f
 3G lens, neutral density filter, 215f
 3G lens, Polarizer, 149f

3G lens, Star Aperture, 144*f*
3G lens, Wide Angle Lens, 232*f*
2.0 lens, 9*f*, 17*f*, 60*f*, 61*f*, 63*f*, 121*f*, 150*f*–153*f*, 231*f*, 238*f*
2.0 lens, Macro Filter, 120*f*, 239*f*
2.0 lens, Star Aperture, 140*f*
2.0 lens, Telephoto Lens, 59*f*
2.0 lens, Wide Angle Lens, 62*f*
Dyer, Peggy (portfolio), 57–63

E

elements, optics, 72
 Fisheye optic, 102
exposure, 28–29
 guess and check tips, 29
 low-light photography, 30
Exposure Compensation function, 28
exposures, blending. *See* multiple
 exposures

F

f/2.8 aperture, 51*f*
f/4 aperture, about, 50, 53*f*
f/5.6 aperture, 51*f*
f/11 aperture, 50, 52*f*
f/16 aperture, 53*f*
 viewfinder brightness and, 54
f/22 aperture, 50, 52*f*
 viewfinder brightness and, 54
f/177 aperture. *See* Pinhole optic
filters
 graduated neutral density filters,
 215, 217*f*
 with Macro Kit, 124
 neutral density filters, 215

polarizers, 214, 214*f*
using creatively, 213–221
Fine-Focus Ring, 13, 13*f*
Fisheye optic, 100–115, 154
 accessory limitations, 124
 aperture discs with, 102
 black border, 104–109
 compared to other optics, 76*f*
 with creative aperture shapes, 138
 vignetting with, checking, 100
Fisheye optic, photos taken with,
 105*f*–112*f*
 bending lens to adjust black border,
 105*f*–108*f*
 Composer lens, 16*f*, 101*f*, 103*f*, 109*f*,
 112*f*, 155*f*, 187*f*, 234*f*
 Composer lens, high dynamic range,
 220*f*
 flare effect, 109*f*–112*f*
flare, 84–85, 84*f*, 85*f*
 with Fisheye optic, 109–115,
 109*f*–112*f*
flash, using, 226, 227*f*, 245
focus, 154
 achieving Soft Focus optic, 93*f*
 achieving with Composer lens, 42
 achieving with Control Freak/3G lens,
 38–40, 154
 achieving with Fisheye optic, 100,
 154
 achieving with Muse/Original/2.0 lens,
 35–38
 achieving with Super Wide Angle
 Lens, 154
 beginner tips, 34
 bracketing, 44

depth of. *See* depth of field
diopter, setting, 33–35
Fine-Focus Ring, 13, 13*f*
letting go of, 167
Live View function, 45
maximizing focusing distance, 11
overlays and, 204–205, 205*f*–209*f*
sensor size and, 129
sharp point, achieving, 35–42
sweet spot, finding, 29–45, 31*f*. *See also*
 sweet spot
troubleshooting, 245
with wide angle lenses, 129, 133, 135
zooming with, 88

G

graduated neutral density filters,
 215, 217*f*

H

happy accidents, 116
Hart, Jerome (portfolio), 190–195
HDR. *See* high dynamic range
Heart aperture disc, 137, 139*f*
high dynamic range, 218–221, 218*f*–220*f*
Hilz, Corey (portfolio), 16–25

I

Image Overlay function (Nikon),
 205, 210*f*
image softness, 50–54. *See also* Soft
 Focus optic
 with Pinhole and Zone Plate optics, 88
ISO, 10

K

Kishiyama, L. Toshio (portfolio), 196–201
Kubota, Kevin (portfolio), 64–69

L

lamppost, as subject, 186, 187f
Layers Panel (Adobe Photoshop), 113f, 114f
lens cases, 146, 146f
lens focus. See focus
lens shade. See Step-Up/Shade
Lensbaby, history of, ix
Lensbaby 3G lens. See 3G lens
 (under "Three")
Lensbaby Community Gallery, 247–248
Lensbaby Composer. See Composer lens
Lensbaby Control Freak. See Control
 Freak lens
Lensbaby models, 4
Lensbaby Muse. See Muse lens
Lensbaby Original. See Original
 Lensbaby lens
lenses, 4
 accessories for. See accessories
 aperture discs in. See aperture discs
 choosing among, 4–6
 custom lens cases, 146, 146f
 optics for. See optics
 summaries of, 7–11
 sweet spot (focus). See sweet spot
 wide angle. See Super Wide Angle
 Lens; Wide Angle Lens, photos
 taken with; Wide Angle/
 Telephoto Kit
light meter, 244

light metering with Pinhole and Zone
 Plate optics, 86
Live View function, 45
 Fisheye optic, 100
 with Fisheye optic, 100
 problem solving, 47
low-light photography, 30

M

Macro Kit, 124–128
Macro Kit, photos taken with, 127f
macro photography, aperture for,
 165
Manual exposure mode, 28
metering with Pinhole and Zone Plate
 optics, 86
models of Lensbaby, 4
moving camera between exposures,
 211
multiple exposures (combined), 113,
 210–213
Muse lens, 5f
 advantages of, 5
 creation of, ix
 custom lens case for, 146, 146f
 Double Glass optic, 249f
 filters with, 213
 Fisheye optic with, 102
 focusing with, 35–38, 44
 how to hold, 38
 Live View function with, 45
 summary information about, 8–10
 swapping optics, tips on, 74
 with video, 227

N

NDs. See neutral density filters
neutral density filters, 215

O

opacity adjustment (in Photoshop), 210,
 210f
optic container, 72, 73f
Optic Swap System, 72–74
optics, 72–74. See also specific optic by
 name
 apertures for. See aperture discs
 experimenting with, 162
 flare and chromatic aberration, 84–85
 selecting, 173–175
 swapping, 73–74
Original Lensbaby lens
 accessory limitations, 124
 creation of, ix
 filters with, 213
 focusing with, 35–38
 how to hold, 38
 Optic Swap System with
 (unavailable), 72
 optical equivalent to, 73
 Single Glass optic, 251f
 summary information about, 8–10
 sweet spot, 29
Original Lensbaby lens, photos taken
 with
 Single Glass optic, 241f
 Single Glass optic, Macro Filters, 237f
Overlay function (Nikon), 205, 210f
overlays, 204–210

P

parking garage, as subject, 173, 173*f*
Photoshop
 combining multiple exposures, 213
 opacity adjustment, 210*f*
Photoshop opacity adjustment, 210
Pinhole optic, 86–92
 compared to other optics, 76*f*
 composing challenges, 88–89
 focus as zoom, 88
 metering with, 86
 sensor spots, 91
 sweet spot (none), 88
 Zone Plate optic vs., 89–90, 245
Pinhole optic, photos taken with, 88*f*
 compared to Zone Plate optic, 89*f*, 90*f*
 sensor spots with, 91*f*
Plastic optic, 82
 aperture discs with, comparing, 51*f*, 52*f*
 compared to other optics, 75*f*
 Soft Focus optic vs., 94
Plastic optic, photos taken with
 Composer lens, 20*f*, 24*f*, 82*f*, 83*f*, 85*f*,
 173*f*, 177*f*, 179*f*, 182*f*, 191*f*, 211*f*,
 225*f*
 Composer lens, Macro Filter, 128*f*
 Composer lens, Telephoto Lens, 170*f*
 Soft Focus optic vs., 96*f*
polarizers, 214, 214*f*
portfolios
 AJ Schroetlin, 148–153
 Corey Hilz, 16–25
 Jerome Hart, 190–195
 Jim DiVitale, 115–116

Kevin Kubota, 64–69
L. Toshio Kishiyama, 196–201
Community Gallery, 247–248
Peggy Dyer, 57–63
Tony Sweet, 154–159
Program mode, 28

R

rainbow flare, 85*f*
reinventing the ordinary, 173–175
removing aperture discs, 48, 244
 with Fisheye optic, 102

S

Schroetlin, AJ (portfolio), 146–154
sensor size, focal length and, 129
sensor spots, 91*f*
shallow depth of field, 42
shapes for apertures. *See* Creative
 Aperture Kit
sharp focus, achieving, 35–42
shoot-through technique, 171
Shutter Priority mode, 28
shutter speed, 10, 38
 exposure and, 54
Single Glass optic, 79–82
 compared to other optics, 75*f*
Single Glass optic, photos taken with
 Composer lens, 18*f*, 46*f*, 80*f*, 185*f*
 Composer lens, graduated neutral
 density filter, 217*f*
 Composer lens, Super Wide Angle
 Lens, 253*f*
 Composer lens, Telephoto Lens, 81*f*,
 164*f*, 165*f*

Original Lensbaby lens, 241*f*
Original Lensbaby lens, Macro
 Filters, 237*f*
Soft Focus optic, 92–99
 compared to other optics, 75*f*
 comparing aperture discs, 94–98
 Plastic optic vs., 94
 special effects with aperture discs,
 99
 sweet spot (none), 32*f*
Soft Focus optic, photos taken with
 comparing aperture discs, 95*f*, 97*f*
 Composer lens, 93*f*, 98*f*, 99*f*, 156*f*, 159*f*,
 183*f*, 194*f*, 212*f*, 227*f*
 Composer lens, Wide Angle Lens,
 192*f*
 Plastic optic vs., 96*f*
softness of image, 50–54. *See also* Soft
 Focus optic
 with Pinhole and Zone Plate
 optics, 88
speed. *See* shutter speed
spots on sensor, 91
squeezing, to focus, 38
Star aperture disc, 138
 photos with, 139*f*–144*f*
starburst pattern effect, 99, 99*f*
Step-Up/Shade, 145, 213
streaking effect, 165–167
subject experimentation, 163
Super Wide Angle Lens, 133–136, 154
Super Wide Angle Lens, photos taken
 with, 224*f*
 compared to Super Wide Angle
 photos, 136*f*

Composer lens, Double Glass optic, 134*f*, 135*f*

Composer lens, Single Glass optic, 253*f*

swapping optics, 73–74

tips on, 74

Sweet, Tony (portfolio), 154–159

sweet spot (focus), 29–45, 31*f*. *See also* focus

achieving with Composer lens, 42

with Fisheye optic (none), 100

multiple exposures and, 205

with Pinhole and Zone Plate optics (none), 88

streaking effect, 165–167

with Super Wide Angle Lens, 133

T

Telephoto lens. *See* Wide Angle/ Telephoto Kit

Telephoto lens, photos taken with

compared to wide-angle-lens photos, 136*f*

Composer lens, Plastic optic, 170*f*

Composer lens, Single Glass optic, 81*f*, 164*f*, 165*f*

Composer lens, Zone Plate optic, 87*f*

2.0 lens, Double Glass optic, 59*f*

3G lens

creation of, ix

custom lens case for, 146, 146*f*

Double Glass optic, 41*f*

filters with, 213

focusing with, 38–40, 44

Live View function with, 45

Optic Swap System with (unavailable), 72

optical equivalent to, 73

summary information about, 11

sweet spot, 29

with video, 227

3G lens, photos taken with

Double Glass optic, 12*f*, 25*f*, 77*f*, 117*f*, 118*f*, 158*f*, 175*f*, 233*f*, 235*f*, 236*f*

Double Glass optic (out of focus), 168*f*, 169*f*

Double Glass optic (overlays), 206*f*–209*f*

Double Glass optic (streaking effect), 166*f*, 167*f*

Double Glass optic, Macro Filter, 125*f*, 126*f*, 157*f*, 240*f*, 254*f*

Double Glass optic, neutral density filter, 215*f*

Double Glass optic, Polarizer, 149*f*

Double Glass optic, Star Aperture, 144*f*

Double Glass optic, Wide Angle Lens, 232*f*

timing the shot, 173

troubleshooting, 254

2.0 lens.

creation of, ix

Double Glass optic, 36*f*, 37*f*, 39*f*, 78*f*, 250*f*, 253*f*

filters with, 213

focusing with, 35–38, 44

how to hold, 38

Live View function with, 45

Optic Swap System with (unavailable), 72

optical equivalent to, 73

Single Glass optic, 253, 254*f*

summary information about, 8–10

sweet spot, 29

2.0 lens, photos taken with

Double Glass optic, 9*f*, 17*f*, 60*f*, 61*f*, 63*f*, 121*f*, 150*f*–153*f*, 231*f*, 238*f*

Double Glass optic, Macro Filter, 120*f*, 239*f*

Double Glass optic, Star Aperture, 140*f*

Double Glass optic, Telephoto Lens, 59*f*

Double Glass optic, Wide Angle Lens, 62*f*

V

video, 227–229

viewfinder brightness, 54–55, 245

vignetting with Fisheye optic, 100

W

Wide Angle Lens, photos taken with

compared to Super Wide Angle photos, 136*f*

Composer lens, Double Glass optic, 131*f*–133*f*, 197*f*, 200*f*, 201*f*

Composer lens, Soft Focus optic, 192*f*

3G lens, Double Glass optic, 232*f*
2.0 lens, Double Glass optic, 62*f*
Wide Angle/Telephoto Kit, 129–132. *See
also* Super Wide Angle Lens

Z

Zone Plate optic, 86–92

compared to other optics, 76*f*
composing challenges, 88–89
concentric-circle effect, 91
focus as zoom, 88
metering with, 86
Pinhole optic vs., 89–90, 245
sensor spots, 91

sweet spot (none), 88
Zone Plate optic, photos taken with
compared to Pinhole optic, 89*f*, 90*f*
Composer lens, 92*f*, 188*f*, 195*f*
Composer lens, Telephoto, 87*f*
zooming, with Pinhole and Zone Plate
optics, 88